# KSI

**DEY ST.**
*AN IMPRINT OF* WILLIAM MORROW *PUBLISHERS*

**DEY ST.**
*AN IMPRENT OF* WILLIAM MORROW *PUBLISHERS*

HarperCollins books may be purchased for educational, business, or sales promotional use. For information please e-mail the Special Markets Department at SPsales@harpercollins.com.

A U.K. edition of this book, *I Am a Bellend*, was published in 2015 by Orion Books.

FIRST U.S. EDITION

*Designed by Us Now*

Library of Congress Cataloging-in-Publication Data has been applied for.

ISBN 978-0-06-244496-7

15  16  17  18  19    OV/RRD    10  9  8  7  6  5  4  3  2  1

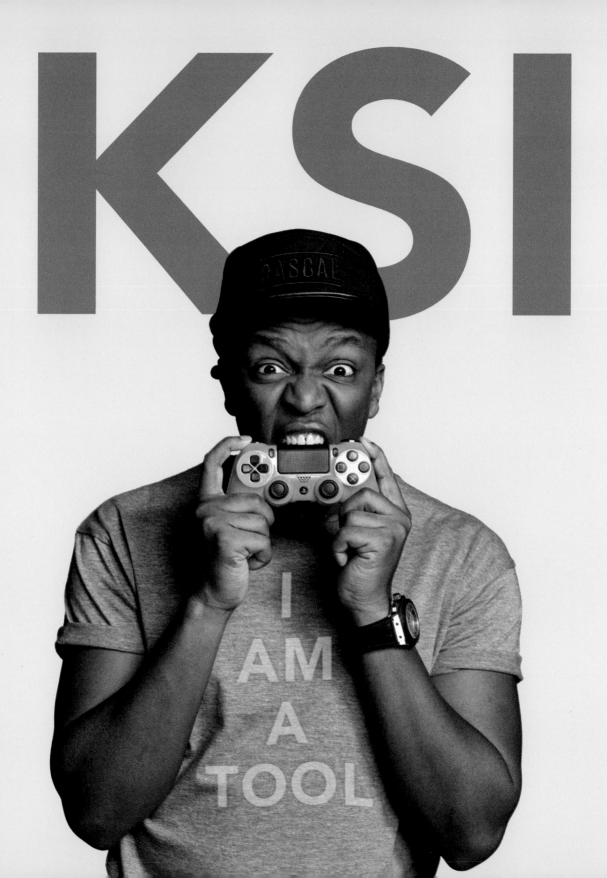

# CONTENTS

# INTRODUCTION

BOOOOMM!!!! It's here you sons of bitches! Your boy KSI has only gone and written a book, and it's big, bad and totally inappropriate. What else did you expect? A book full of blank pages, with shit challenges and some really deep lifestyle tips? Do me a favor! This shit is legit.

But first, let me tell you all something you might not know . . . I. AM. A. TOOL.

It might sound complete madness but it's true. I spend my whole life taking selfies, filtering pictures, talking shit to gamers, wanking to porn and making my mates laugh. Psychologists might say I'm a product of an environment that encourages such behavior online, and that I'm no different to millions of others, but if that's true then we are all fucked!

But I wasn't always a tool. Hold up. Stop laughing. Let me say my piece. You see, back in the day I was just some quiet, skinny black dude, who wouldn't say shit to nobody. I was a total dweeb. And then I discovered the internet . . . Ever since I first went online, and got knee deep in porn, it's all been downhill. Sometimes I wonder, would I have become a tool without the internet, or was I already destined to become one anyway?

So, with this in mind, I thought I would take a long hard look at myself and the online world we live in, to see where I'm going wrong. And I gotta tell you, it's absolute mayhem out there. It's a wonder we don't all spend our days locked in a room wanking our brains off . . .

Anyway, you guys better buckle the fuck up, 'cause over the course of this book I'm gonna cover how to be a baller on YouTube, how to use the internet to get laid, as well as look at the crazy-ass shit we all do on social-media that has led me to become the tool I am today. Finally, I'm gonna rip up the game, and put some ideas out there about how we can make the internet our bitch.

Now, I've got a lot of things to get off my chest, a lot of scores to settle, and a lot of fit ladies to admire, so without further ado, let's murder this mo-fo!

## OLAJIDE OLATUNJI
born on 19 June 1993

Timeline | Videos | Photos

**YINKA OLATUNJI**
This is my beautiful baby boy.

**JIDE OLATUNJI**
He takes after his dad ; )

**OLAJIDE OLATUNJI**
Hope your dick's grown by now, Dad, otherwise I'm fucked!

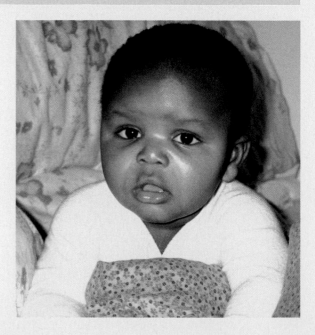

**OLAJIDE OLATUNJI** Just ate a cracker and shit my pants. Now going to suck some milk from my mom's tits. 👍

**OLAJIDE OLATUNJI** Likes **RUGRATS** 👍

**OLAJIDE OLATUNJI** Likes **HEINZ CHICKEN BABY FOOD** 👍

# MY BADASS WORLD OF YOUTUBE

I pretty much owe my life to YouTube. If it wasn't around I would probably still be re-sitting my A-levels or working in KFC! No joke.

When YouTube rocked up in 2006 I was just a shy, skinny kid with not a lot to say for myself. Hard to imagine now, I know, but this shit totally changed my world. I started to watch dudes like Hjerpseth drop badass FIFA videos, and shit like that you just couldn't get on TV, so I was crazy mad for it.

Soon I set up my own YouTube account, but I needed a name, and that is when KSIOLAJIDEBT came to be. Why? Well KSI is a Halo clan I used to be in, Olajide is my name, and BT stands for British Telecom. I know, random as fuck, but back then I didn't know shit would blow up so much and didn't think it was important.

Initially I tried to do my own FIFA videos on the PC but it was hard, man, and it took a lot of time to work out what equipment I needed and how to edit my videos. And I gotta tell you, this was all like my dirty, dark secret. I didn't tell anyone what I was doing, 'cause I didn't want to look like a total dickhead, so I had to wait until my parents were out, or my bro had settled the fuck down, before I could even shoot shit. Seriously, back then I'd rather tell people I was a wankaholic than a YouTuber.

But, y'know, over time my videos got better, and so did my FIFA skills, and by 2011 this shit totally took over my life as I started to delve into commentating, and bitching about flaws in the game. By then all I could think about in school was how to make better videos and it's no wonder I ended up flunking all my exams. Sorry Mom : /

Sure, I made a few fuck-ups along the way, but I've gone from having nobody watch my videos to having well over a billion views, which blows my mind. Yet while YouTube is a serious biz these days it's still a mystery to some. Kinda like why anyone would support Spurs? ; ) Anyway, because I always get asked, and because I'm in a good mood, I thought I would show you all what goes down, and how you could become a YouTube star yourself. But I gotta warn you, this shit isn't for pussies, so brace yourselves!

# A DAY IN THE LIFE OF A YOUTUBER

People say being a YouTuber isn't a real job. That just pisses me off. Like, REALLY pisses me off. This shit is as real as a night shift in McDonald's. So, if you want to know what an average day on the YouTube front line is like, I'm blowing the doors off.

**2.30 PM  WAKE UP**

Being on screen most days I need my beauty sleep so I'm telling you, that alarm better not go off before midday. Want a morning meeting? Not today, bro. KSI is getting some serious sleep in.

**2.37 PM  RELIEVE THE TENSION**

The first wank of the day is a major affair. Seriously. This is huge. People say breakfast is the best way to start the day but those people have obviously never jerked off. And as it's the first one, this is an epic, earth shuddering, cum festival.

**3.02 PM  PLAY FIFA**

This is the hardest bit. Just having to pick up the controller can be a task in itself. Sometimes I lose the damn thing, or it's in bits from the previous day's tantrum. Anyway, when I do finally have it ready to roll, it's time to face the public with my FIFA skills. But I'm telling you, man, this can be frustrating, especially if they know it's me. It just seems like everyone becomes a complete sweaty dickmonger when they play me, scoring and passing around the back. It just pisses me off and costs me a fortune in repairing broken furniture. AAAARRRGGHHHHH! #fifarage

**4.11 PM  RELIEVE THE TENSION**

*Sigh* Man, so after all that hard work I need to loosen up. And what better way than to crack open the Kleenex and hit Brazzers.

**4.47 PM  READ MY FAN MAIL**

Now I'm in a good mood, and it's my favourite part of the day: reading fan comments to my most recent videos. So, here we go . . .

'You're a waste of your dad's cum.'

Well, surely it can't get worse than that . . .

'Go back to Africa you cotton pickin' coon.'

Dayum! Well, now that I'm upset I guess I gotta...

**5.09 PM  RELIEVE THE TENSION**

Crying and wanking isn't any fun but it's what gets me through the days. Although I gotta admit, three wanks in less than three hours can get painful, but I'm a trouper. And remember, I put myself through this hell for my fans.

**5.36 PM  GET SOME FOOD**

I'm lightheaded after all that work so it's Nando's time. But can you believe those fuckers don't deliver? Seriously, it's the twenty-first century! They can put a man on the Moon but can't deliver a Nando's? Fuck! I can't believe I actually have to leave the goddamn house. I'm telling you man, if Nando's don't start upping their game I'm gonna have to start hitting up the Burger King delivery.

### 6.41 PM DO MY WASHING

I pride myself on looking fresh but washing clothes is a bitch. That's why my housemate, Josh, gets his mom to do it for me. I pay her well so it's all good. Although I gotta make sure I clean up the wank stains from my boxers before I hand them over, those bad boys are like cardboard. Let's hope she doesn't read this.

### 7.04 PM RESEARCH

To prepare properly for my videos I'm all about putting in the hard work and doing my research, so I immerse myself in the latest stuff to hit YouTube: spots being popped, epic fails, sick skills and animals doing funny shit. You've got to stay on top of current affairs if you want to do great videos.

### 8.00 PM SHOOT A VIDEO

After hours of playing FIFA, and doing my research, I've got the perfect idea for my next video: playing five-a-side with my boys, The Sidemen. But it's a fucking hassle booking a pitch and getting down there. I'm telling you. Sometimes I think I would be better off just sacking it all off and going back to school. JOKES!!!

### 9.30 PM GET SOME FOOD

After all that running around I need to replace the calories so it's time to hit up the KFC drive-through in the Lambo.
'I'll have a Boneless Banquet.'
'What size?'
'Large.' *Cheeky wink*

### 10.11 PM FINDING THE ONE

It's been a long-ass day but after giving up so much of it to my fans it's time for some me time. Swiping right on every picture on Tinder I look for the love of my life, but so many of these girls keep asking if I just want to fuck. They're relentless. I'm not a piece of meat, y'know. LOL ; )

### 2.45 AM POST THE VIDEO

After spending hours editing the video, thinking it's pretty shit, hating myself, crying and wanking in a spiral of depression, I post it anyway. And people like it! Damn, I'm good. Time to . . .

### 3.12 AM RELIEVE THE TENSION

I've gone well past the point of pleasure. By now just dust is coming out, but as the video hits a million views I'm entitled to a joyful celebratory wank whether my dick likes it or not. Take it dick, AAAHHHHHH!

# HOW TO BE A YOUTUBE BEAST

I'm going to get serious for a moment. No joke. No, really! Will you at least let me try? LOL.

Ok then, a lot of people ask what they need to do to set up their own YouTube channel, and I say, unless you're a complete dick washer anyone can do it.

So, without further ado, here is all the stuff I use for recording my gaming content, as well as some tips.

### 1. GAMING CONSOLE

Straight in at No.1 – if you're thinking about making gaming videos it should go without saying that you'll need a console. In fact, if you don't even have a console, what the hell are you thinking? Move along. Nothing to see here.

### 2. GAMES

Now that you have a console you'll want some games to play. But let me stop you right there. If you're setting up a YouTube gaming channel you're gonna want to stand out from the crowd. So, if you are gonna play games that already have plenty of channels dedicated to them, like FIFA or Minecraft, then you'd better have something new to offer. For instance, no girl has ever played FIFA naked. Just an idea . . .

Alternatively, look out for new games that no one is really talking about yet and set yourself up as an expert. Or just play a load of random games. Either way, it's all about making things seem fresh and exciting.

### 3. ELGATO

Ladies and gentlemen, now we are getting into the serious shit. Most of you probably have consoles and games already, but Elgato sorts the men from the boys. If you are going to make gaming videos, you're gonna want to show your viewers what's going on in the game, and this is where Elgato comes into its own, as it can record and stream as you play.

Note: If you're a PC gamer, then either use Fraps, Bandicam or Dxtory to record your gameplay.

### 4. CANON 700D DIGITAL CAMERA

Most YouTubers not only film the games they are playing, but they also film themselves. I'm a big fan of the Canon 700D for when I'm actually sitting at my computer. It's a pricey bitch but it's well worth it. But, if you're strapped for cash and just starting out, the Canon 500D does a pretty good job, and you can pick up second-hand ones on Amazon without having to resort to blowing old dudes in train station toilets.

### 5. SONY HANDYCAM

*Hold up, I need to get two cameras? Da Fuq! I'm not made of money, KSI!* Stop moaning like a bitch! If you want to make good videos you'll need two cameras so just hear me out. Like I said, the Canon is great for stationary filming, but every now and then you'll want to do stuff on the move, and this is where a Sony Handycam comes into its own. Got that? Good!

 **6. MICROPHONE**

Ok, so you're gonna need to let people hear what you're saying, right? Well, for something so crucial I use a Rode Podcaster microphone, which gets the job done, and then some. And if you really wanna be fancy, you can get a Rode Swivel Mount Studio Microphone Boom Arm, which just means you won't have to hold the microphone in your hands while you record.

**7. SONY VEGAS**

So, you've recorded your game footage, as well as some footage of yourself. What next, KSI, I hear you ask? Well, now the hard work begins. You need to edit all the footage together, as well as add some music and graphics. I know. This shit is hard goddamn work, but if you want to make a great video then you'll need to Man the Fuck Up and buy Sony Vegas. As usual, there are some pretty good guides on YouTube on how to actually use it, and you might even stumble across how to get it for free...

**8. YOUTUBE TO MP3 CONVERTER**

Sometimes you'll hear some cool tunes or sounds on YouTube and you'll want to put them in your own video. But how? Easy! Use this website: http://www.youtube-mp3.org

**9. YOUTUBE ACCOUNT**

Ok, you've got a pretty sick video, and you're ready to unleash it onto the world, but before you do that you're going to need a YouTube account. And you're also going to have to think up a pretty cool name for your channel. But you don't just want to slam it in there and get it over and done with. You need to treat it like you would a beautiful woman. You'll need to take your time and see what name works best. It's important that you make it as memorable as possible, and for the love of God don't add numbers in your name. zoella280390, I'm looking at you!

**10. NAME YOUR VIDEO**

This is huge so listen up. It's not enough to have a great video – you'll also need a good title for it.

Firstly, you want to make sure the title isn't the same as any other videos on YouTube, as this can affect your ranking and lead to confusion. Secondly, if you really want to be serious then check out your title in Google's Keyword Planner. This will show you if the words you're using are ones that are regularly searched, as the more people looking for the words in your title the better.

Obviously, the words 'Cheryl Cole Vag Blaster' will be very popular, but it's unlikely to have anything to do with your video, so if you want to avoid pissing people off make sure your title actually reflects your content. And if you do have a video dedicated to any parts of Cheryl Cole then hit me up!

## 11. SOCIAL-MEDIA

Sit back and relax, you're officially a YouTube star. *But, KSI, no one has viewed my video!* Chill, alright. Unless you get lucky, or do something truly epic, then it's a sad fact that 99% of YouTube videos get lost. But it's ok, here's a top tip.

Rise above the crap by setting up dedicated social-media accounts that are connected to your YouTube channel. You'll definitely need Facebook, Twitter, Instagram and Snapchat, and you'll also need to be coming up with specific content for all of those channels. *But, KSI, I only want to do YouTube videos!* Tough shit, kid. I only want to sit in my pants and wank all day but do I get to do that? Well, yeah, I do, but you're missing the point. Now, where were we . . .

## 12. HARD WORK AND LUCK

I'm not kidding around, this is the most important thing you'll need to make it as a playa on YouTube. The more work you put in, the better your videos, and the more people will watch them. And to really hit the big time you'll need one of your videos to go viral. I wish I had the magic answer to how to do this, but often it's just down to luck or some epic fail. Seriously, though, if you do make a mistake just make damn sure you film it. YouTube loves a cluster fuck!

And remember, sometimes you'll post a video, expecting it to blow up, and it will just plain bomb. Man, I learned the hard way the first time one of my videos was put on Machinima. I sat back and waited for everyone to love my shit, but instead peeps just wanted to kill me. It got so bad I had to have a YouTube time out for a few months. But I got back to it, improved my game, and soon my videos started getting popular. So if one of your videos does go bad, just suck it up, and keep going. I mean, peeps must have been telling Emile Heskey he was shit since he was a kid, but that dude kept going and ended up playing for England! Goes to show!

Now that you're armed to the teeth with all the secrets of the trade you're well on your way to ripping up YouTube. But just make sure you don't get too good, otherwise I may have to pay you a visit ; )

# GETTING PAID ONLINE

Man, if I had a penny for every time my mom told me that when I was a kid, I would be pretty damn rich. And y'know, even today I hear people say that you can't make a real living online. Well, I'm gonna give you guys the lowdown on just how it is possible . . .

## PORN

Apparently over 30% of data transferred across the internet is porn, so there are plenty of sites looking for a hot young black dude to satisfy their ladies. And those sites will pay up to $1,000 a scene for the best in the business. Sadly, they haven't used me yet, despite my sick audition video and massive cock. C'mon, Brazzers, call me, man, we need to talk : )

## CLINICAL TRIALS

There is a lot of easy money to be made online, and this shit is too goddamn easy. Just Google 'Clinical Trials' and you'll see some whacked opportunities to get paid for doing absolutely nothing. In 2014 NASA even paid some dude £11,000 just to lie in bed for three months! While that is definitely the sweetest gig of all time, you can still make some decent bucks doing stuff like testing out different drugs (not the kind you're thinking, LOL). Although you gotta watch yourself, as some peeps have died from doing this shit, and in 2006 one trial even turned some dude into The Elephant Man. Dayum!

## SPERM DONOR

Like wanking? Who doesn't! Want to get paid for doing it? YES!! Then just check out sperm-donor clinics online, where you can get paid around £35 every time you bang one out. This is truly living the dream. I'd be a goddamn billionaire on this ride. However, you gotta be careful, as while it's all fun and games now, you could end up having hundreds of children banging on your door in years to come, asking to see their father. Fuck!

## SELLING YOUR PARENTS' SHIT ON EBAY

Will your parents really miss their TV? How about their jewelry? Of course not. So why don't you sell that shit on eBay! Plenty of people are running full-time eBay businesses, and with all the crap your parents have in the house you're already fully loaded with inventory. However, I have to warn you, it's a good idea to ask their permission first. My dad was pretty pissed when he couldn't find his golf clubs . . . Sorry, Dad : )

## HACKING

Learn to be a badass hacker and the world is your oyster. Seriously, once you've mastered the art of hacking you can break into online banks, steal people's identities, and even hold corporations and governments to ransom. When 'Guardians of Peace' hacked into Sony Pictures in 2014, they not only were able to steal loads of movies that hadn't been released yet, but they even managed to get them to postpone the cinema release of *The Interview*. That's a whole new level of gangsta right there! However, if you do want to earn the big bucks as a hacker then prepare to be on the most-wanted list, and eventually to be the prison bitch. To be honest, I'm way too pretty for prison, so I would stay well clear of this one.

Ok, chill, all of the above is just for jokes. While you definitely can make money in these ways, I wouldn't advise it. Anyway, I know what you all really want to hear is how the hell do YouTubers, like myself, make a living. Am I right? Well, I've broken down the basics for you:

When you click on a popular YouTube video there's usually an ad you have to watch before you get to the good stuff. And this is where most YouTubers make the bulk of their dough. So, how does a video get an ad attached to it, and start making it rain? Well, it works like this:

a) The YouTuber goes to a multi-channel network and says, 'Hey guys, if you want you can put some ads in my videos.' And they're usually like, 'Ok, cool.'

b) Next up, an advertiser approaches the multi-channel network and says, 'Here's some money. Find me a cool video that is suitable for my brand.' And the network goes, 'Consider it done.' And they go away and do just that. Often the YouTuber doesn't even know anything about it. I once found one of my videos was advertising tampons! Da fuq! Anyway . . .

c) Finally, someone clicks on the YouTuber's video, where the ad plays at the start, and it may also include pop-ups throughout. And here's the important part: each time someone watches the video the YouTuber earns a small sum from the advertiser. More views = more money. It's as easy as that.

TIP: I've been accused by some sons of bitches of being a money whore, as a lot of my videos are pretty short, but that doesn't really benefit me financially. You see, it works like this: the longer the video, the more ads the network can include, and therefore the more money the YouTuber makes. Got it now, you dumb fucks? Good. Now you can chill the fuck out before getting up in my grill.

So, there you go, the next time your parents or teachers tell you it's impossible to make a living on YouTube, you can make them eat this page. My work here is done. Let's just roll this shit along!

# WHY GUDJONDANIEL IS A COMPLETE TOOL

BOOOM! Ok, here it is. You've asked for it for sooooooooo long, so I'm giving to you. Sit back and brace yourself for the epic true story of my feud with one-time good friend, GudjonDaniel. We're going in hard! Let's do this.

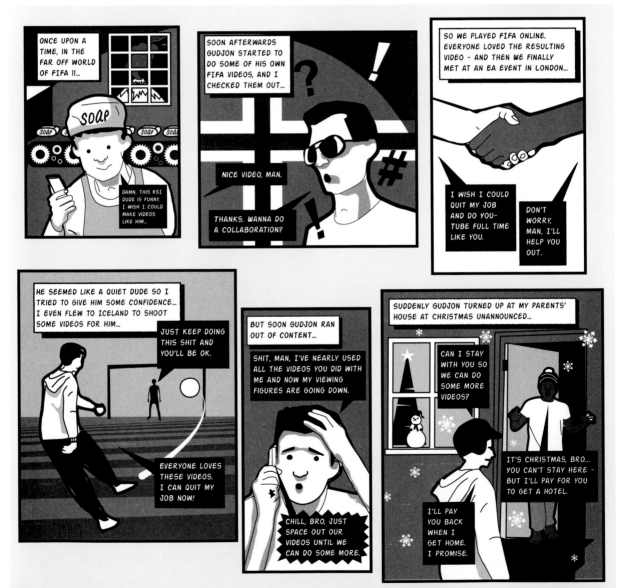

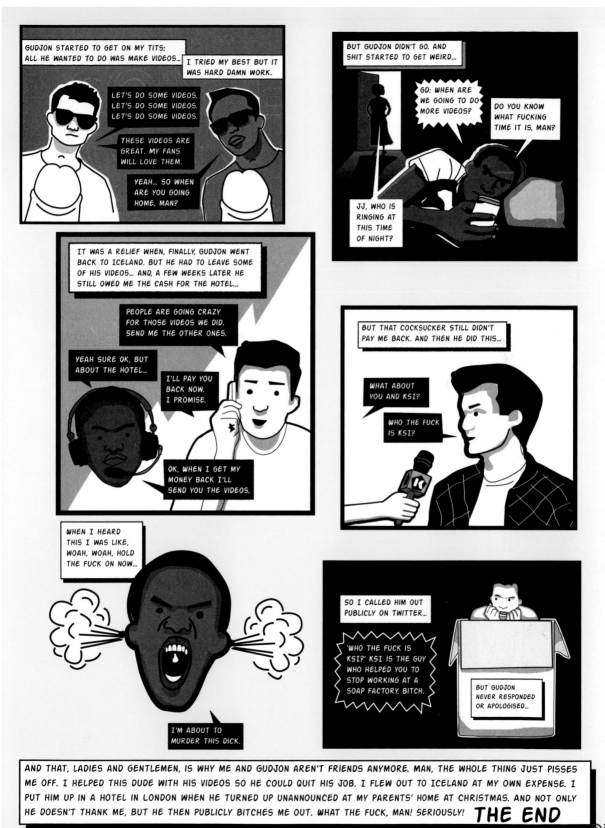

# MY YOUTUBE BROS

Ok, you sons of bitches, now that I've shared the dirty, dark, secrets of YouTube you might be wondering who I like to watch myself. While there might be a lot of plebs out there, here's a badass list of the sickest YouTubers in the game today, endorsed by none other than me!

## SPORT

### freekickerz

Want to know how Ronaldo gets that mad topspin on his freekicks? Then these dudes can show you how it's done, as well as a few tricks to merk your mates with.

### F2 Freestylers – Ultimate Soccer Skills Channel

My boys Billy Wingrove and Jeremy Lynch are the F2, and these dudes have skills to pay the bills. So, if freestyling like a pimp is your game, then watch and learn.

### SkillTwins – Tutorials – Gameskills – Freestyle

These two crazy fools are legit players. Coming straight out of VSK, one of Sweden's top football academies, they are proper bad boy skillers.

### STRskillSchool

Like street skills set to some phat beats? Who doesn't?! Go watch this madness! It's mind blowing.

### Footballskills98

The guy loves his sliders, but I gotta hand it to him. For someone 3–4 years younger than me (and I'm only 21, LOL), this guy has some mad skills.

## GAMING

### penguinz0

Now, a lot of you might go WTF when I mention this guy, but to me he does the funniest gaming commentaries on the whole of YouTube. He's monotone as hell but I think that just adds to it. His content is simply pure gold.

### VanossGaming

A funny guy, with funny friends, commentating on funny gaming videos, edited extremely well. That's it. And it's pretty goddamn hilarious.

### Markiplier

The guy cries too much in my opinion, but don't let that take away from his hilarious videos. His commentary on games is on point (especially because his sound quality is unreal) and he is generally just a very funny dude.

### Aidrianoo

Ah, yes, Aidrianoo. A FIFA gem. His sarcastic humor hurts my sides and he definitely deserves more people watching his stuff. This guy also did a video on using my mom in pro clubs as well. Too jokes!

### PewDiePie

How could I not put this guy in here? The guy is mental, and loves playing funny, stupid, perverted, scary and random games. And with his enjoyable editing, you'll definitely have a good time watching his videos.

## COMEDY

### Nigahiga

I have been watching this guy since he made the 'How to be a ninja' video, and somehow he has remained consistent for all these years. You can't fault his videos – they're just too goddamn funny!

### LifeAccordingToJimmy

Jimmy Tatro has done pretty well for himself, popping up in a few movies here and there in recent years, but for me it's all about his YouTube videos, which are fricking hilarious.

### BlazinSkrubs

THIS CHANNEL IS MAD. That is all.

### Egoraptor

Animated, random, craziness. So wrong it has to be right!

### OneyNG

Take some of your favourite characters, turn them into cartoons, and make them do sick shit. You don't even understand how fucked up this is. It's like a window to my brain. I love it.

# FOOD

### Epic Meal Time
Do you like so much meat you can't even get your face around it? Course you do. So brace yourself for a heart attack because this shit is for real.

### Nicko's Kitchen
Want to know how to make fast food at home? How about a KitKat lasagne? What the hell is that? Well, this dude has all the answers.

### Rosanna Pansino
Cute chick makes cupcakes. Me likey.

### BBQ Pit Boys
Take that, meat! Take it, bitch! That's pretty much what this channel is all about. Big old slabs of juicy prime-time meat thrown on the grill with no mercy. Uhhhhh, get in my face.

### SORTEDfood
Man, after all that meat you're probably gonna have a pretty sweet tooth, so how about a cupcake burger? Sounds disgusting, right? But go to this channel and check out this complete madness for yourself!

# THE SIDEMEN

If you enjoy my videos then please make sure you check out my boys The Sidemen, who do similar shit to me, and are all goddamn brilliant! Some of us actually live together as well, so you might even see me pop up in their videos.

### Vikkstar123
My boy Vikkstar123, AKA Vikram Barn, is probably best known for videos on Call of Duty, Grand Theft Auto and Minecraft. This dude always kills me and gets major props for his raw chicken fights during 'Minecraft Hunger Games', which basically saw him punch his enemies to death with a raw chicken during a deathmatch, before setting them on fire and shouting, 'I NEED TO COOK MY CHICKEN!'.

### Miniminter
Ah, Simon Minter. What a chilled dude to live with. Not only does he make some badass FIFA vids, but some pretty cool vlogs too, which usually document what we all get up to. Sometimes, though, we have to tell him to put the damn camera away 'cause he catches us at bad times. LOL!

### TBJZL

My boy Tobi is my brother from another mother. He's black. I'm black. It's all good, and he makes some damn entertaining videos on FIFA and GTA. Check out his 'Chocolate Men' FIFA vids! Epic shit!

### ZERKAA

Josh Zerker is not only a fellow FIFA YouTuber but he also mixes it up with random games and even challenges, like eating bugs. Why the fuck you would do this, I don't know, but it is hilarious nevertheless!

### Behzinga

People say my laugh is funny, but Ethan's is a whole new level. This guy laughs at everything! There's a lot of speculation online as to whether my boy might be gay. He won't confirm or deny, but it's cool, bro, we love you either way! But if you do like FIFA, GTA, and random games then pay him a visit

### Wroetoshaw

Harry is the youngest of all of The Sideman and still doesn't shave, but don't worry, bro, one day we will both have big-ass beards, and then who'll be laughing? Nobody, that's who! Another FIFA rock star, this guy gets as excited as me when he opens a good pack, or when FIFA is complete bullshit, which is all the time these days.

### ComedyShortsGamer

You didn't think I'd forget to big up my little bro, Deji, did you? Well, I did, but he promised to get me a Nando's if I gave him a shout out, so check out his channel ComedyShortsGamer, for gaming videos, comedy and family shenanigans! How he manages to rope our parents into some of his shit I'll never know!

# KSI'S SCRAPBOOK

Thanks to YouTube, and all of you guys who watch my videos and support me, I am truly living every young guy's dream. For real, man. Over the last few years I've got to do some ridiculous things and have met some sick people. Crazy to think that all this began after some skinny bellend filmed himself playing FIFA back in the day . . .

Watching my big mouth as my boy Amir Khan shows me how to box.

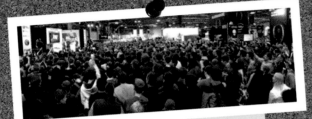

Unreal support from my fans at the Gadget Show Live back in 2013.

Liam from 1D asking me to join the group now Zayn has jacked it in.

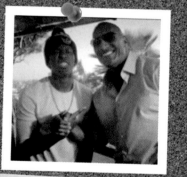

Getting to meet my hero The Rock after seeing the Fast and Furious 7 premiere in LA.

Feeling like a proper balla playing FIFA on stage at G3! This was a sick feeling being in front of so many people.

Plenty of VA VA VOOM in this pic, with my idol Thierry Henry.

Always good to catch up with my boy, Lethal Bizzle!

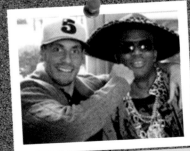

When you're playing FIFA against Rio Ferdinand you gotta look the part!

Dream come true: signing for Sway's record label.

Oh yeah, chilling with Alex Oxlade-Chamberlain, and my manager, Liam Chivers, after I took The Ox back to skool during our FIFA matchup for BT Sport in October 2013.

Man, even though I'm having LOLs here I'm still sore after losing my FIFA match-up with Emmanuel Frimpong!

Rocking BBC Radio 1, chatting about YouTube and shit.

Probably my favorite pic. Getting to help out at an orphanage in India!

Me and Calfreezy totally blown away by the incredible Dynamo.

YES! Me and Arsenal ledgend Ian Wright doing some work for the Sun.

27

# YOUTUBE BEAST FACTOR

Now I've explained all the rules of the YouTube game to you guys, I'm probably gonna have to go work in McDonald's. Jokes! There's more than enough room for us all to entertain the masses, and I love seeing mad new channels anyway. So, if after reading this you are thinking of setting up your own YouTube channel, then listen up, 'cause I've decided to get all Simon Cowell on your ass.

I'm running a challenge where I'm inviting everyone who has set up a new YouTube channel to tweet me the link at @KSIOlajidebt, with the hashtag #KSIBeastFactor, and I'll pick my favorite. After that I'm gonna give this new channel some mad props all over social-media, sharing it with my millions of followers so they can get a taste of your mad skillz, and hopefully help you build a fan base in the process. I remember how hard it was to get people to watch my shit when I was starting out, so I'm gonna give the winner a helping hand.

What are you waiting for? Get filming some crazy-ass shit that is gonna make me LOL hard, and who knows, it could be you writing a book like this one day!

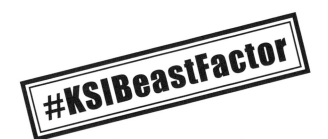

# KSI'S Q&A PART 1

When I started writing this book, I put a shout-out on Twitter for you guys to ask me any questions you wanted me to answer in this book, kinda like how we do on YouTube. And guess what? As usual, some of you asked some pretty fucked-up stuff, LOL. However, as I like to keep you guys entertained, I'm gonna step up to the mark, and get down to business. So here we go . . .

## THE SIDEMEN

**@weaton96 How did you meet The Sidemen?**

Alright, we'll start off with Josh. I met Josh through YouTube. He was a YouTuber way before me and was like an inspiration, so once I started to get near his level we just began to talk, and we were chill.

I've known Simon for too frigging long. In fact, since Year 7 in school. Oh, God, I've had enough of him now. We live together and everything.

As for Toby, well, I actually met him through Josh, as those guys were good friends, so that was pretty easy.

I knew Ethan through Josh as well, as he used to watch Ethan's streams and thought they were cool, so they started talking. Then he started to hang out with us and we realized he had a crazy laugh. Oh, man, his laugh is amazing! And he's got a great personality too. So we thought, why not add him to the group if he's got nothing better to do?

We met Harry through YouTube as well. He was actually doing really good, and we saw he had some bantz, so we chucked him in and ran with it.

Looking back now, it's crazy to think that none of this was planned. It all just happened naturally. It's not like we were recruiting for The Sidemen or anything. It pretty much just happened because we all initially liked playing GTA together, and people started to tag along until there was seven of us. Seven seemed like a good number so we stopped there. Now we're known as The Sidemen and it's all gone cray.

**@Hydrosteel13 Who is your fav of The Sidemen?**

I don't have a favorite, to be honest. They're all dicks!

**@idanielchannel If you had the opportunity to remove one of The Sidemen, who would it be?**

Ummmm . . . I don't think I could remove anyone. In fact, I'd probably just remove myself and save them from me, LOL.

## DEJI

**@CrazyTurq66 What do you think of Deji?**

Absolute dick washer.

**@HyphyAR Worst fight you've had with your brother?**

We've got in so many fights, I can't count. We fight all the time. We even fought when we went to see The Rock in LA! He just pisses me off. For fuck's sake, man, I just want to slap him in the face. Sometimes it gets proper violent. We really go for it. My parents always take his side as well, so I can't properly fuck him up. To be fair, all our fights are the worst. They just seem to escalate every time.

**@Adam_1885 I've been in one of Deji's Q&As – can you make it 2 bros out of 2, please???**

No . . . Ah, fuck it, go on then.

# KSIBOOK

## OLAJIDE OLATUNJI
### born on 19 June 1993

Timeline | Videos | Photos

**SIMON WHITE** Saw your mom in the playground after school. She's got huge tits!!!

> **OLAJIDE OLATUNJI** She's pregnant you dick!
>
> **SIMON WHITE** I know ; )
>
> **OLAJIDE OLATUNJI** You're 4 years old! WTF!!!!!

**OLAJIDE OLATUNJI** Got a baby bro today. Check out his Fro! LOL!

**OLAJIDE OLATUNJI** Man, I love a good party! Aaaarrgghhhhh!

**OLAJIDE OLATUNJI** Likes **ACTION MAN** 👍

📍 **OLAJIDE OLATUNJI** checked in at **NORTHWICK PARK HOSPITAL**

**JAMES YARDLEY** What's wrong, bro?

**OLAJIDE OLATUNJI** Hungry man. For real! Check me out! Wasting away!

📍 **OLAJIDE OLATUNJI** checked in at **KFC**

 **OLAJIDE OLATUNJI** Just tried **KFC** for the first time ever. Dayum! Not hungry no more!

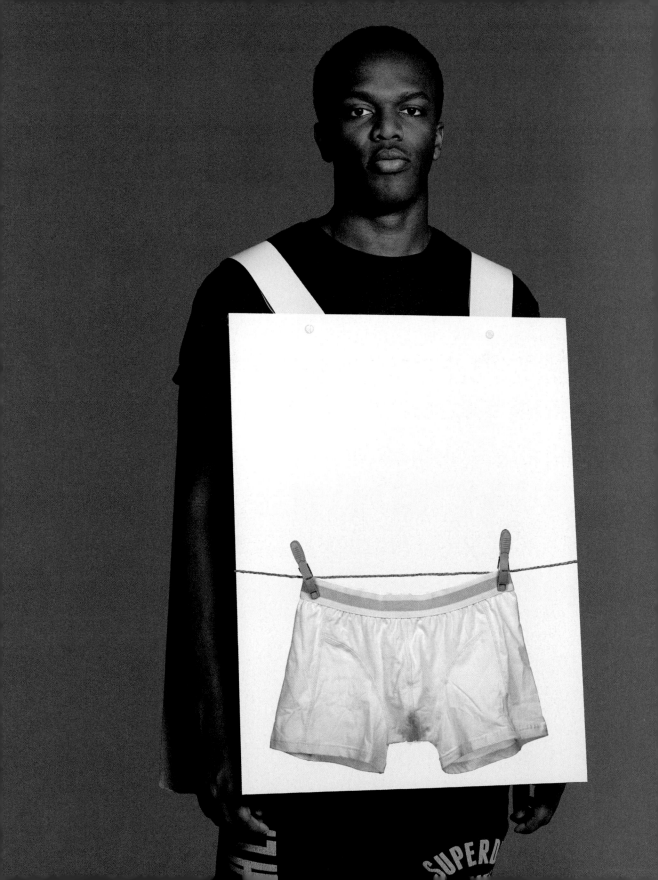

# LOOKING FRESH ONLINE

My beauty regime is real simple: I get out of bed, and that's it! Sure, I brush my teeth, slam on some BO basher and have a wash, but that's as far as it goes. I'm a man for fuck's sake, and I got shit to do. However, while in real life I might not make much of an effort, looking good online is becoming mega serious.

You see, in real life I might bump into a handful of people in any given day, so I don't worry about what I look like. But online I've got millions of peeps checking my mug out! And, I'm pretty sure it's similar for everyone these days: more people will probably check out your Facebook profile picture each day than will actually physically see you. Makes you think, doesn't it?!

So, in order to look my best online I did some research, and checked out all the shit us bros need to know to spruce up our image. You don't even understand how much of a tool I feel doing this shit, but I'm telling you, it's goddamn necessary!

# BEAUTY TIPS, KSI-STYLE

Ok guys, listen up. Like I said, looking good online is becoming major. The girls already take this to extremes and have YouTube beauty channels and everything to help them out. But where do guys go? Well, judging by some of the monstrosities that walk this earth, absolutely fucking nowhere, so I'm here to lend a hand, 'cause there are some things that even the best filters can't help you with.

I hear you reading this right now, and saying, 'KSI, you must be fucking crazy if you think I'm taking beauty advice from you.' But trust me, some of you BO-stinking, monobrow-wearing, pimply fuckwits need to hear this. Listen, I've been there, man, and it meant I spent my teenage years wanking myself into oblivion.

So, go through this checklist, and if you have to stop at any of them then simply follow the advice. You'll thank me later. Trust me.

## APPLY FAKE EYELASHES

Alright, here we go. Go into your mom or sister's room and locate their fake eyelashes. Put them on. Look in the mirror . . . Now slap yourself for being so fucking stupid. Paying attention? Ok, let's get into the serious stuff.

## TRIM YOUR PUBES

It seriously astonishes me that some guys still walk this earth without trimming their pubes. Don't you want to make your dick look as big as possible? Anyway, a word of advice if you haven't trimmed the bush yet: never, ever use a razor. Sure, it might look as smooth as a baby's bottom afterwards, but last time I did this I was itching my cock for weeks. My mates were all saying, 'Dude, what's wrong with your dick?' So, to avoid looking like you've got an STD, always use scissors.

And when you do give yourself an all-over trim, please remember: treat your crotch with respect. No one wants a bloody crotch.

## POP YOUR ZITS

Go to a mirror right now. Yes, right now. Look at yourself. Do you have any spots? Are any big creamy fuckers ready to erupt? If so, what the fuck is wrong with you? Why are you walking around with that on your face? Pop it now, for fuck's sake. But, if it's a really juicy one, make sure you film it. Popping spots is big business on YouTube so you might as well use it to your advantage.

## MONOBROW

Repeat after me, 'Monobrow is a Mono-No!' Ok, are we clear? If your eyebrows are joining together in the middle of your head it's a problem. But whatever you do, don't shave it! Sneak into your mom or sister's room, find their waxing strips, apply to the middle of the brow, and rip away. Hurts, doesn't it? But at least you don't look like a werewolf anymore.

## TANNING

Living in the UK we get absolutely no sun, which sucks, but sometimes you need to get some color in your face so you don't look like a vampire. However, if you're black, you don't need a sunbed. You're tanned enough. Leave this to the white kids. And if you're white, don't overdo it . . .

## WHITE BOXERS

*WTF has this got to do with looking good online?* Ever sent a dick pic, or are you thinking about it? Well if your pants are in the picture you don't want any skid marks to ruin the mood. While white boxers don't show up your wank stains, they do show up your skid marks! I don't care how vigorously you clean your ass, there's always one bit left behind that causes mayhem. And nothing is less sexy than a major shit stain running through your boxers. I actually still have nightmares of my mom shouting, 'JJ, will you start wiping your bum properly!' when we had people round the house. Fuck!

One more thing: wearing Y-fronts is scientifically proven to lower your sperm count, and us guys need all the spunk we can give. Remember, the more spunk there is, the better your wank will feel.

## FACIAL HAIR

Dude, I want a beard so bad. I honestly envy everyone who has a beard. It just makes you look so much more manly and the ladies love it. But even though I'm in my twenties I can't grow shit! It's total bullshit. However, I'm told that if I shave every day it will encourage the fuckers to grow. But if you can grow facial hair already, you mature mo-fo, then there are some fuck-ups you need to avoid, like moustaches!

I want you to think long and hard about this: who looks good with a moustache? Answer: no one! It's a scientific fact. Well, it's not, but it should be. Moustaches are a bit shit. Either shave it off, or grow some stubble. BUT . . .

If you can't grow proper facial hair then for fuck's sake don't bother, unless your aim is to look like a giant pube, in which case, carry on.

## SHAVE YOUR ARMPITS

*Ha ha, KSI, that is so funny. I'm not falling for that.*
No, I'm being serious. Hear me out. The hair clings onto smells, so the more BO you get, and the more deodorant you use, the more the hair will smell. And no one likes BO. I once had a friend in school, and God help his soul, he had the worst BO. I used to have to tell him, 'Dude, you fucking smell.' But he just didn't care. He ended up old and alone, smelling of BO. That's actually a lie, I don't know where he is now but he probably doesn't have many friends, or a girlfriend. Anyway, the point is, do whatever you can to avoid BO.

## NO MAKE-UP

Now, while some people don't take enough pride in their appearance, there are some who take too much. Did you know that some dudes wear make-up these days? No, not trannies, everyday dudes. Seriously, brands like Tom Ford and Marc Jacobs actually sell male eyeshadow and bronzer! If you have ever bought any of these have a look at yourself. No girl likes a guy who spends longer than her in the bathroom.

## A TIP FOR WHITE GIRLS

While we are on the subject of make-up, here's a tip for white girls. If you are dating a black guy don't overdo it, unless you want to turn your boyfriend into a ghost every time you kiss him.

# KSI'S ALTERNATIVE GUIDE TO GETTING FIT

Uh, the gym. Fuck that shit. It's so boring!

When I do drag myself there I usually stick to the same old routine: treadmill, rowing machine, a few random weights, all the while checking out any fit females in the vicinity. It's probably no surprise that this regime isn't exactly packing on the muscle, but I'm trying, man, as everyone on social-media looks so ripped! Seriously, I can't go online without looking at some dude who looks like he's an extra from *Game of Thrones*.

Thankfully, these dudes, and ladies, are always happy to tell us mere mortals how they got so fit with some words of supposed wisdom, usually in the form of a wanky hashtag on a filtered Instagram picture. So, eager to follow their example and get in prime shape, I decided to check out their advice . . .

## EAT CLEAN. TRAIN DIRTY

Ok, now I get that eating clean is a surefire way to lose weight, but damn it's boring. And anyway, in my experience, if you want to lose some serious pounds, then hitting up a dirty, all-you-can-eat buffet gets the job done a lot quicker. After doing this I was proper sick, man. Like proper sick. Pooping. Puking. Crying. The works. Food poisoning is a bitch! But after two days I lost a stone. That's more than a baby weighs. So, yeah, if you're serious about losing weight then food poisoning beats eating clean every time.

Train dirty? What does that even mean? It sounds like an invitation to wank yourself silly, so I did, and I measured my calorie burn with a Nike FuelBand. It turns out that every wank equates to 120 calories burnt. Damn! When studies show that the average person burns 390 calories in a gym workout then all I need to do is wank around four times a day. Time to cut up that LA Fitness card and join Pornhub!

## DO YOU EVEN LIFT, BRO?

Man, trying to get on the weights bench at peak gym time can be a bitch. And do you really want to ask the skinhead, covered in tattoos, how long he is going to be? Not really. But buying weights to use at home is expensive, and can take up a lot of space. So, what we need are cheap, disposable, multi-use weights, right? Well, KFC Bargain Buckets are pretty damn heavy. You get where I'm going with this? Buy two Bargain Buckets, connect a pole between the two, and you've got yourself a bench press, not to mention a tasty treat for later. Chicken is protein, right?

## FRIENDS DON'T LET FRIENDS SKIP LEG DAY

Me and my bros know this only too well. After all, when you're watching your weight you need to know that a KFC hot wing only has 125 calories, compared to a KFC chicken breast that has 258 calories. So, next time you and your boys hit up the Colonel, be a friend, and remind them not to skip legs.

## RUN LIKE RYAN GOSLING IS WAITING AT THE FINISH LINE

Alright, this has been doing the rounds lately and it confuses the shit out of me. Have you seen Gosling in *Drive*? Or how about *Only God Forgives*? That dude can be scary when he's not in shit like *The Notebook*, which, by the way, is the ultimate date movie. Anyway, just think about it, if Ryan Gosling was actually waiting for you at the finish line then that would be crazy. I'd run for miles in the other direction. So, yeah, in a weird way I suppose this is pretty good advice.

## AVOID CRAMP, STRETCH REGULARLY

Exercise can be goddamn hard work and getting cramp hurts like a bitch. That's why this is one of my favourite sayings. After any intense workout you don't want to walk anywhere. You need a stretch limo. After all, it has a TV, a fridge with food and drink, and lots of space to stretch out in. Plus, girls love a limo, so even if you haven't worked out and are still carrying a few extra pounds, this is a surefire winner. So, do as you're told, and 'stretch regularly'.

## NOTHING TASTES AS GOOD AS SKINNY FEELS

Those who know me know that I love a cheeky Nando's just as much as a KFC. That stuff is like crack, not that I know what that feels like, but it surely can't be better than a hit of PERi-PERi sauce. BUT, have you seen Melanie Iglesias? Man, that is one beautiful woman, and I'm pretty sure feeling her would give a Nando's a run for its money. So, yeah, I guess nothing does taste as good as skinny feels.

Man, it's no wonder those dudes on Instagram are so ripped with advice like this. But, if you're like me and that sounds like way too much hard work, then just flip across to the next page for the 'Cheat Mode'.

39

# KSI'S BEAUTY CHEAT MODE

After all that advice you might be looking a millions times better than before, and be ready for your profile picture au naturel. But if, like me, you're lazy as fuck and can't be bothered spending hours on your hair, hitting the gym and going on a diet, then don't worry, 'cause here I present you with 'Cheat Mode'.

You see, thanks to apps, these days it can take just two seconds to be whoever you want to be online without any ridiculous bullshit. So, always happy to find a shortcut, your boy KSI has road-tested some of the most popular Photoshop apps in the game today to come up with the perfect social-media profile picture. Here we go . . .

## ABS BOOTH

It's virtually the law these days that all dudes have to post a picture at sometime in their lives showing off a six-pack. But man, getting that six-pack can be hard work, and who wants to go months without KFC? Not me. So, this app promises to mould the perfect six-pack onto your body, and it looks pretty damn good. I'm sold. Next.

## FATIFY

Alright, alright, calm your tits. Why would anyone want to make themselves look fat? I know, it's crazy, but back in the day I was skinny as fuck and actually had to see a doctor because I wouldn't eat enough. So, when I was a kid this app might have worked out ok. Now, not so much . . .

## FACETUNE

Michael Jackson spent a fortune on plastic surgery trying to get the perfect nose. And, after all that time and money, he still looked pretty shit. But this app apparently means that if you're not happy with how you look, you don't have to go under the knife anymore, as you can alter your appearance in just a few seconds. So, I decided to follow Michael and go for a smaller nose and lips. Fuck, man, it ain't pretty.

40

Michael Jackson was also famous for turning himself white. He was one crazy dude, but I decided to give it a go anyway, and see if I could succeed where he failed . . .

What the fuck is that? I've seen some shit in my time, but seriously?

Alright, it's pretty clear that trying to copy Michael Jackson is a shit idea. But what if he got it wrong, and should have tried to make himself more black?

You know what, this whole thing is fucking wrong. Let's just move it along.

## HAIR MAKEOVER

Sometimes you just want to rock a different hairstyle but can't be dealing with the hassle of growing it out, dying it, or paying big bucks to those Barbershop wannabe's. But this app apparently lets you pick your perfect style. Let's see how we get on...

Well, that's horrendous.

**THE ROCK 'N' ROLL STAR**

**THE BIEBER HAIR**

**JUST CURIOUS**

**70s MODE**

But I ain't done just yet. What about facial hair? These days all the cool kids have bushy beards or hipster moustaches, but not all of us can grow them. Let's do this.

YES! Finally, a beard! And I look so fucking cool! But even though I know moustaches are wank, I wonder what I would look like with one . . .

As I thought, a complete dong.

47

## BABY FACE

I thought that turning my face into a baby's might make me look cute, or even younger. Turns out I look like a mole. Madness.

## OLDBOOTH

Man, we've all been there, wanting to be a few years older so we can buy some booze, or get into a club, and this app promises to do just that. But WHAT THE FUCK IS THIS? Why would it turn a black kid into a white old man? What the fuck, man. I look like a perv.

## BREEDIFY

There was me thinking, cool, an app that turns me into other people, this should be sweet. But when I asked to be turned into a celebrity it did this! You sons of bitches! You could have turned me into The Rock, but no. Apparently the best thing to do is to turn a black kid into a white chick. Fuck, man, I wouldn't even fuck myself looking like this.

But hold on, we're not done just yet – how about a gangsta? If I was going to jail looking like this, I know I'm about to be somebody's bitch. What a pussy! Alright, last chance – how about an action star?

Dayum! Now we're talking. Eat my bullets, bitches!

## MY VIRTUAL BOYFRIEND

I'm not gonna lie. Most of us are trying to find the perfect profile picture to impress the ladies, so why don't we just dive straight in and find out what the hell they want? This app takes all of your details and apparently turns you into the perfect boyfriend, so, technically, it should solve all of your problems. Although when I gave it a go it said I should be called 'Terell' and look flaming. I dunno, ladies. Is this really what you want? 'Cause if it is, I'm going about my whole image all wrong.

## CUT ME IN

'Have a pussy in your picture,' they said. 'Cool!' I said. 'Here you go, then,' they said. 'Meow,' I said. Fuck!

But this app still has its uses. Want to show off to your mates, and impress the ladies with some action shots, without ever leaving your bedroom? Well, here you go, then.

# MIXBOOTH

But wait, hang on a second. I've been going about this all wrong. Why try to improve yourself when you can just be someone girls fancy already? This app allows you to merge faces with whoever you want to be. It's the best of both worlds. So, take a bit of KSI, and a shitload of Justin Bieber, and what do we have? This goddamn handsome dude. Man, this is sick.

But hold on . . . what if we put this all in the mix, using the best of all these apps, to come up with the ultimate profile picture?

So, here we go: we MixBooth my face into Bieber's and add a hipster beard and sunglasses from Hair Makeover. BOOM! I'm about to have a wank over myself, I look so good.

So, there we have it. Don't waste your time actually improving yourself – just be a tool, use some apps, and live your life. I'm done here. Peace!

## UGLY SELFIES

When I was writing this book I was sick to death of selfies being posted all over social-media. It was getting goddamn ridiculous seeing the same old posed shit, usually with a trout pout, of peeps trying to act like they were models. Who the hell seriously wants to see this fucking crap? Not me! I'm on the internet for one thing, and one thing only: LOLs.

So, knowing that my fans are as fucked up as me, I put out the call for you all to send me your funniest selfies. And man, did you guys answer with some fucked-up shit! But I gotta tell you, they made me laugh my ass off, even if some of you need to be locked away for the good of society.

Anyway, here is a selection of some of the selfies that deserve to be immortalized in this book. One of these days you're gonna have a family, with kids and stuff, yet here you will be forever, looking like a prize tool. And you know what, I salute you for it.

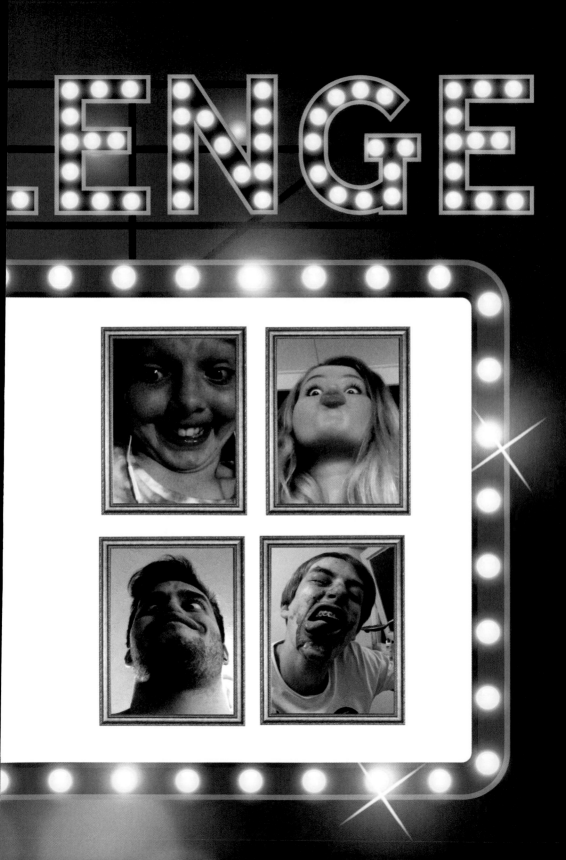

# KSIBOOK

## OLAJIDE OLATUNJI
born on 19 June 1993

Timeline | Videos | Photos

**OLAJIDE OLATUNJI**
Likes **FIFA 2000** 👍

**OLAJIDE OLATUNJI** Man, this FIFA game is blowing my mind!

**DEJI OLATUNJI** Let me play!

**OLAJIDE OLATUNJI** If you don't want what The Rock is cooking I suggest you pipe down!

**OLAJIDE OLATUNJI** checked in at **REDDIFORD INDEPENDENT SCHOOL**

**OLAJIDE OLATUNJI** Likes **THE ROCK** 👍

# FINDING YOUR BAE ONLINE

Alright, after my tool grooming and beauty tips we should all look like masterpieces right now. But that's just the first step on the way to complete tooldom, 'cause now we need to know how to score online.

All I can say is, Thank Fuck for Tinder. Before this shit came into my life I had zero dating strategy. Unless I was out of my mind drunk I would never go up to a girl in a bar, and no girls ever came up to me, so I was completely fucked. I'm not messing around. I was so bad with the ladies. I had zero game and didn't know what the hell to say.

But thanks to Tinder we now live in a world where within seconds you can meet a total stranger online, send her a dick pic, and, as long as she doesn't laugh, arrange to fuck. It sounds like heaven, and it is, but still I gotta tell you, there are a lot of pitfalls you gotta watch out for. And I should know. I've made every mistake in the book . . .

# KSI'S TINDER ADVENTURE

Imagine, if you will, a world before Tinder. It's not pretty. Dudes actually had to approach girls for real! Scary shit. But these days all you have to do is swipe right on every picture, wait for someone to swipe right back, send them a cheeky message, and before you know it you're blowing them away with your cum gun. Sounds easy enough, but let me tell you, Tinder is a minefield. And, oh man, have I had to learn the hard way . . .

Before I knew my shit I was meeting up with peeps from Tinder left, right and centre. I was one horny mo-fo. But something quickly became apparent: a lot of the girls I was meeting looked nothing like their profile pictures. Serious! They were either Photoshopping them to hell and back or were completely scamming me, using fake pictures. Yo, I'm down with us all trying to look our best, but this shit was just ridiculous. I was well and truly catfished!

If you do meet up with someone who is damn fine you still gotta be careful. Sure, it's all fun and games getting down with someone incredibly fit, but sometimes their personality is dog ugly. Some of the girls I've met up with were totally batshit crazy, mad stalkers or wanting to do some seriously freaky stuff in the bedroom, which was even too far for me – so you know that shit has got to be wild! I don't care how good looking a girl might be, if she ain't got a chill personality then that shit will wear thin pretty quickly.

And then we come to dick pics. Now this can get you into a whole world of trouble. Sure, when you're horny as hell, and the sexting is getting cray, it might seem like a good idea to send her a picture of your throbbing bad-boy. This is modern day *Romeo and Juliet* stuff. I know. I've been there. But remember, the stranger you just sent your dick pic to has that shit on her phone forever! And if you go and mess her about there is the real danger she will post that shit online!

I've had this real fear a few times now, and it made me goddamn sick 'cause I got an online rep to uphold, and I don't want any of my mates seeing me go down like that. But in the end I realized it wouldn't be so bad if a dick pic did leak, as my dick is a monster! I'm black! What can I say? : )

You might think I would have learned something from all this craziness. That, after being a total dick, I might go on some sort of epic journey the hashtag hippies bang on about and emerge a better, more enlightened person?

But guess what? I'm still on Tinder, making the same mistakes, and continuing to meet up with total strangers with mixed results. I know. I know. I'm a total tool, but you know what? It's either hit up Tinder or approach strangers when I'm out and about, and despite all my bravado I'm way too much of a pussy to do that : (

Anyway, the point of all that is to show you guys that Tinder isn't for amateurs. You need to do your homework and know what you're doing. So, learn from all of my mistakes by checking out my Tinder Tips on the next page!

## SWIPE TO THE RIGHT

Tinder is a numbers game. You don't even need to look at the pictures, just keep on swiping to the right, then take your pick of the best matches. Seriously, I don't think I've ever swiped left in my life. Remember, right is right!

## PROFILE PICTURE

This is a big one. To get over the first hurdle, of getting a girl to swipe to the right, you need to be looking your absolute best. Girls have all the power on Tinder, and they have a lot of choice, so you can't be going into this half-assed. Like I said before, with Photoshop apps there is absolutely no excuse for a shitty profile picture. In my experience, the best profile pic would be a Justin Bieber lookalike, with his top off, standing next to a Ferrari, stroking a kitten, in Las Vegas, while it's raining money. If you can get close to that you won't go far wrong. As for me, I just flat out rely on my fame and use my official KSI picture ; ) Why lie? Fame definitely helps!

## LIE!

For God's sake don't be yourself on Tinder! This isn't a job interview, and you're not looking for the love of your life. Everyone is on there for one thing, and one thing only – sex! So, you can be absolutely anyone you want to be. Big yourself up to the max, without sounding like a dick, and you will do a lot better than just being yourself.

## WANNA FUCK?

If you could see my phone from when I first went on Tinder it's pretty embarrassing. Every girl who showed any interest in me, I immediately hit them up with, 'Wanna fuck?' And not one of them responded. Seriously, not one. Now listen, we all know that's what you're both on Tinder for, but you've got to at least lay some groundwork before you broach that subject. I would give it no less than 15 messages before you wade on in there. And sometimes it definitely pays to get to know someone properly before you go too far.

## LOCATION

Location. Location. Location. If you actually want to meet this girl you want to make sure that before you even speak she lives near to you. I can't tell you how frustrating it is when you've got yourself talking to a hot girl, and she's really into you, only to find she lives miles away. There's no way you are going on that road trip without a stone-cold commitment that shit is going to go down!

## INVESTIGATE

While you might not like doing homework in real life, you gotta do it on Tinder. If you think us guys are Photoshopping our asses to the max in our profile pic then you can be sure that the ladies are doing the same. So, do yourself a favor, go on Google Images, put her Tinder profile picture in there, and see what other pictures of her are online. You'll thank me later.

PHEW! And all that is just for starters. Once you've found a match then the hard work really begins . . .

# THE ART OF SEXTING

After all that advice, you're now messaging someone on Tinder. You big, bad playa! That's stage 1 over and done with. But now you're entering the danger zone, where you can either be the smoothest customer in the game, or look like a serial killer. I'm serious, man. This is the stage where you've got to calm your dick down and play it cool. Listen, I'm as guilty as any man on getting this all wrong, but when sexting goes badly, it can be disastrous. So, if you want to avoid having pictures of your dick all over the internet, you've come to the right place.

## GET THE RIGHT PERSON

First things first. You'd better make damn sure you're sexting the right person. When men are horny we literally go insane, and that can lead to mistakes. So, just take a second and make sure you're not accidentally sending the messages to your mom!

## PLAY IT INNOCENT

You want to make it seem like you're just chilling and she's the one hounding you for sex. I know, tough, right? But not only will she find this funny, it will also get her thinking about having sex with you. Following me? Now listen, you've got to misinterpret everything she says, like she's trying to seduce you. If she says something like, 'Let's meet for a drink?', you say something like, 'You just wanna get me drunk so you can take advantage of me!'. Get it? Be funny! Ok, let's move this along.

## FOREPLAY

I love *Breaking Bad*. It's one sick show. By the last episode I was like, 'Holy fuck, this is mindblowing shit.' But if I had just seen the last episode, without any of the previous ones, I probably would have been, 'Meh'. And the same applies to sexting. You can't just go right into the final episode, you've got to take your time and build towards it, so starting the conversation off with, 'Wanna fuck?' is out of the question. If you can ramp up the anticipation then, who knows, she might be the one sending you a tit picture out of nowhere ; )

Again, being too horny is dangerous. You might be a foreplay master, but when you get into some real hardcore sex talk you still need to tread carefully. This isn't a free-for-all. Sure, you might be into some sick shit, but she might not, and nothing will end a sext session quicker than you sounding like a sex offender. Who knows, maybe you'll get lucky and she's into that stuff as well – there are a lot of strange cats out there – but go slow on the freaky stuff, man. For real!

A word of warning. Don't just send a dick pic out of nowhere. It will Freak Her the Fuck Out! Seriously. Chill. And something else you definitely need to consider: sending a dick pic can have some badass consequences. Do you really want to take the risk of your dick being shown to her friends, and possibly posted online? Who knows, maybe you do, but just take a moment before you press send.

**DICK PICS**

Let's be honest here. Dicks aren't that great to look at. So, if you are getting the 'send me a dick pic' vibe, you'd better make damn sure your dick looks like Leonardo da Vinci has crafted it himself. It needs to be a work of art so it's vital you make it look as big as possible, get the right angle and the right lighting. And if you haven't got a big dick don't worry, that's what Photoshop is for. At least this way, if she does show it to her friends, and it gets online, you can be proud of your monster cock.

Follow

CONTACT

CALL

CHAT

Email

**SLANG**

Alright, if things are really getting wild then you need to keep up that momentum. You want her begging for your next message and sending them back as quickly as possible. In everyday texts you might be too lazy to write whole words, so you'll use lots of slang instead. I get you. But when sexting try to limit the slang. You don't want to be getting her all horny, only to have her look twice at your message and think, 'What the fuck does that mean?'

Like I said, good sexting is all about building momentum, and as things are heating up I'm sure your dick is getting ready to blow. But what happens if she suddenly stops messaging? Frustrating, right? But just chill – don't start bombarding her or getting mad. She might have a good reason to stop, so just play it cool unless you want to be in Tinder jail.

**CHILL!!**

**DRUNK SEXTING**

We've all been there. Had a good night out, got drunk, went home horny, and alone, and started bombarding girls with messages. But let's be honest here, how often has that actually paid off? Unless the girl is drunk as well, I can guarantee the last thing she wants to happen is to be woken up by a picture of your dick. So let's keep this real simple: don't sext unless you're both drunk or both sober, otherwise you'll have to do what I do, and send a text the next morning saying, 'JOKES!!!'

You might be sending and receiving some of the sickest messages and pictures known to man and think you're ripping Tinder up. But let me tell you something, nothing will get you in shit quicker than if you show your mates what's been going down. Seriously, if she finds out you're sharing this with the world it's game over.

**DON'T BE A DICK**

**PRACTICE**

I know, it's a lot to take in, and you might blow at this stuff to begin with, but how did Ronaldo become the best player in the world? Practice. Practice. Practice. So, before you start hitting up your Tinder bae, you might want to check out some chat rooms, which are free, and interact with other horny peeps just like you. If you fuck up there then it's no problem, you can just move right along until you get it right.

55

# KSI'S DATE NIGHT

Oh, yeah, you've scored. Uhhhhhh, you big stud! You met your girl on Tinder, maybe shared a sneaky sext session, and you've moved it into the real world with a date. But now you've got to show that you match up to your online persona of a big-dick hunk or you'll look like a total tool. No pressure!

But just chill, bro. KSI is here with some tips you can use in real life, which will have you avoiding any awkward moments like a pro, and hopefully have her inviting you back to hers at the end of the night. Man, I really need to listen to my own advice! I sound like a proper playa here, LOL.

## HAVE A WANK

Yup, that's right. Make sure you have a wank BEFORE you even leave the house. Nothing is more dangerous than going out there with a loaded gun. You want to be relaxed and not have your dick going berserk, so take control and calm the demanding brat down.

## MAKE AN EFFORT

This really should go without saying, but for God's sake have a shower, put on some aftershave, wear some fresh clothes and do whatever you need to do to make yourself look less like a tramp. C'mon, bro, you're not getting any if you stink. This is real life now. People can actually smell you in the real world, y'know!

## PREPARE

This might sound psychotic but it's very necessary. Nothing kills a date faster than lots of awkward silences, so look her up, see what type of stuff she's into and know that shit cold. That way, if the conversation does hit a rocky patch, you've got questions to fall back on rather than saying something totally random that will have her dialling 999 to be rescued from your boring ass talking about playing FIFA. And be funny! Girls love to laugh.

A word of warning. While you are probably on a date looking to get some, sometimes things don't always go so smoothly. I was once on a date and this girl just started crying about her parents and shit. It was real awkward, and ended with her sobbing on my shoulder. At moments like that just put all thoughts of sex to one side and be cool.

## TUNES

If you're picking her up in your car then you might want to give your choice of tunes some serious thought. Playing some hardcore hip hop on the way to the gym is all well and good, but the same tunes on a date could spoil the mood. And this doesn't mean you have to start playing Barry White or nothing, just pick something cool and chilled. Drake or Usher is usually a good call.

## ACTION

You want this girl to be having the best time of her life with you so don't be taking her anywhere boring like the cinema. Most people tend to go for a meal, but then the pressure is really on you to come up with something interesting to say for two hours. So, why not do something like bowling? That way the action covers any uncomfortable silences, it gives you the opportunity to rip the piss out of each other, and, if it's heading that way, you can heat things up by holding her waist and showing her how to bowl. Alternatively, if you're really shit, you might ask her to give you some pointers. I'm telling you, man, bowling is the way forward on a first date.

## READ THE SIGNS

It's the end of the date, and usually this is the dealmaker or breaker. Are you going to get the big invite inside, or go home and wank yourself to death? Usually the best time to tell is right at the very end, as you get to her house and go in for the end-of-date hug. Now pay attention, this is key. As you go into the hug, or as you pull away, see if she lingers a little longer than normal. It might be just a split second, but if you spot it then it's time to go in for the kiss. And when it comes to the kiss, don't go straight in and attack her with your tongue. You're not a cow! But if she does pull away from you then run for your life. You've completely blown it.

## FOLLOW UP

Whether or not you were invited inside, if you want to see this girl again you need to send a follow up text. It doesn't need to be anything crazy, something like, 'Awesome seeing you. Let's do it again soon . . .' should do the trick. Sometimes you've got to play the long game to stay in the game.

And if she doesn't like you after all that advice, then face facts, you're probably a dick!

# KSI'S KAMA SUTRA

Bravo, bitches. You've sailed through the lessons, got yourself a banging bae, had a good time on your date, and now you're ready to get down and dirty. But hold up, let's just rewind here. I consider myself to be a man of the world, and I've watched a lot of porn in my time, so I should be a black belt in the bedroom. Yet even with all my years of 'experience', I'm still stuck in a missionary rut. Man, I know all sorts of slick moves, but sometimes I completely lose my head in the moment.

So, first things first, remember this isn't just about you. I guarantee that if she's having a good time then you'll definitely have a good time too. Better yet, you could even be in with a chance of making this a regular hook-up if you impress between the sheets. And, who knows, in time your Tinder bae could become something a bit more serious. With so much at stake you gotta check out my Kama Sutra for some of the sickest moves in the game. Master them all, and before you know it you'll be a bona fide porn star!

## SUPERMAN
Just let your girl strap herself in and imagine she's riding Superman at Six Flags, which is what she will be calling your dick after this ride. This move has got enough thrills to give any theme park a run for its money.

## STRICTLY CUM DANCING

Man, this kinda looks like you're doing the tango together, and girls love to dance, so this is a surefire winner. You'd definitely get a perfect 10 from the judges if you could pull off this move.

## THE FART EXCHANGE

WTF is going on here? Are you just meant to bump asses and fart on each other, or is your cock actually meant to bend around? Man, I'm pretty sure I would snap my cock in two if I even attempted this! Not for the faint-hearted, or those of you with a small dick.

## THE PUSH-UP

Sometimes you want to go all out and impress a girl, and what better way than proving you're a bad boy in bed AND you can knock out push-ups at the same time. This would be a killer cardio session. Give me 20!

### THE MUTUAL FAVOR

Oh, yeah, I'm definitely down with this one, as this way you both get in on some fun. A word of warning, though: when you're both ready to blow just make sure you don't drop your girl on her head!

### THE PIGGYBACK

Y'know, sometimes you just need a break from putting in so much effort, and you need a drink to cool the fuck down. However, you're horny as hell and don't want to stop. I get you. Well, this is the perfect solution, as you can keep the action going while your girl carries you to the fridge. Kudos to any girl who can carry her man like this!

### THE SUPER SLIDE

Do you remember hitting up the super slide when you were a kid? Well, this is no different, except you are the mat and your girl is enjoying the ride! Just make sure you have a firm hold of her. You don't want any accidents!

## THE CRAWL

For maximum penetration, and for making sure your girl isn't subjected to your hideous cum face, then look no further than The Crawl. However, with your ass crack in full view of your girl, you'd better make sure you've given that bad-boy a thorough clean, otherwise you're gonna kill the mood pretty damn quickly.

## THE RKO

If your girl has banged you into submission, and you're lying there just waiting to be tapped out, bear The RKO in mind. With this move all you gotta do is pull your leg up and your girl has got access to keep the party going.

## THE WTF!

I can't see how this would be pleasurable for either of you but, man, this is the ultimate test, 'cause if you can both get down like this then you and your girl can do just about anything. Just make sure you leave the Icy Hot nearby in case you pull a muscle, but for fuck's sake DO NOT USE IT AS LUBE!!!

# BUILD-A-BAE

No surprise, after all that advice it's got me thinking about beautiful women. Man, there are some hot ladies out there, and I should know, I've Googled most of them! But what if I could build my perfect bae? That would be goddamn epic. So, as this is my book, and I'm allowed to do whatever the fuck I want, I've done just that. Check out this stone-cold beauty – she would be getting hit up left, right and centre on Tinder!

We've got the stunning face of Melanie Iglesias, the epic breasts of Kelly Brook, the tight stomach of Cheryl Cole, the junk of Nicki Minaj, the long legs of Pixie Lott, and the toned arms of Olivia Wilde. Get out of my dreams and into my bed!

But in Build-a-Bear you get to stuff your toy once you've put it together, so what would I stuff my bae with? I'll leave that to your imaginations, you dirty mo-fos...

FACE – MELANIE IGLESIAS

STOMACH – CHERYL COLE

ASS – NICKI MINAJ

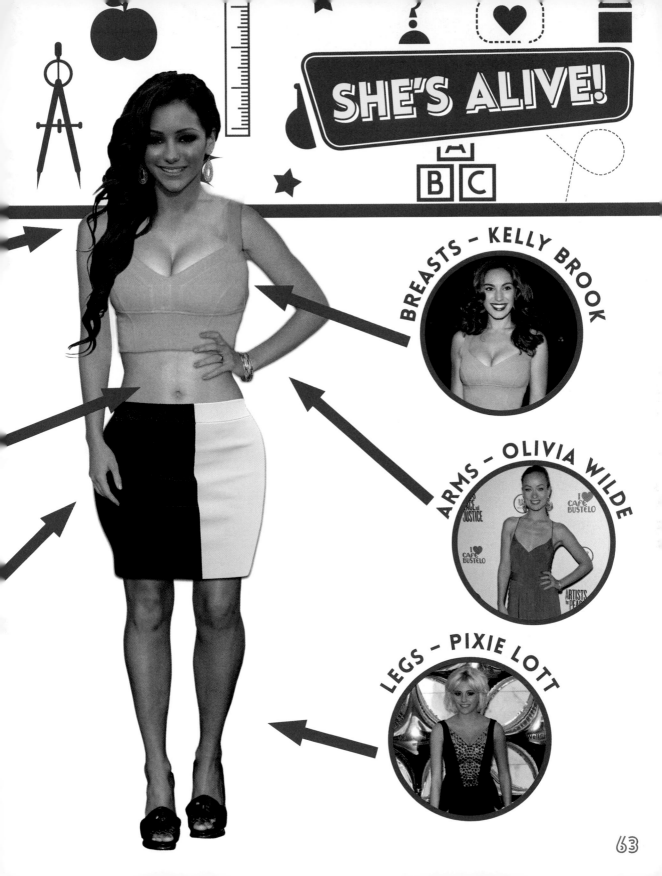

SHE'S ALIVE!

BREASTS – KELLY BROOK

ARMS – OLIVIA WILDE

LEGS – PIXIE LOTT

## OPENING TINDER LINE CHALLENGE

As you've seen by now, starting a conversation on Tinder with, 'Wanna fuck?' ain't gonna get you anywhere. But it's so goddamn hard to know what to say when you're about to speak to someone really hot. If you're anything like me you get brain freeze and end up saying something totally ridiculous.

So, knowing that I've got some total playas as fans, I put out the call for you bad-boys to show us mere mortals how we can up our game with some smooth opening chat-up lines. Now, some of these are stone-cold genius, while some just make me think there's no hope for society. Either way, here are some of my favourites.

**ISAAC REED**

If you were a sink, I'd tap you.

**DAN SWANTON**

Are you Heskey?... Because I want to take you for Emile.

**DANIEL SMITH**

Do you work in Subway? Because you've just given me a footlong.

**JACK PAYNE**

Do you buy your clothes on sale? As they're 100% off at my place.

## OLAJIDE OLATUNJI
### born on 19 June 1993

Timeline | Videos | Photos

 **OLAJIDE OLATUNJI** First poem I've ever written and it got published! #natural

TALENT FOR WRITING

THIS IS A CERTIFICATE OF MERIT TO CERTIFY THAT

*Olajide Olatunji*

WROTE A POEM OF DISTINCTION THAT WAS SELECTED FOR PUBLICATION IN A YOUNG WRITERS ONCE UPON A RHYME ANTHOLOGY

**JOSH MELLOR** shared **TUPAC SHAKUR'S VIDEO** Check this out **OLAJIDE OLATUNJI**

**OLAJIDE OLATUNJI** Nice, man, but I'm loving Breaking Benjamin right now!

**OLAJIDE OLATUNJI** Likes **ARSENAL FOOTBALL CLUB** 👍

**OLAJIDE OLATUNJI** Just the four goals today! When's Arsene Wenger gonna call ? : )

On Thursday 9th October, the under 11's B team played a match against St Christopher's. The match was away at their ground and the final score was 10 –0 to Reddiford, but they did have four regular players missing. It was still a convincing win, with our goal scorers being Olajide Olatunji 4, Conor O'Brien 3, Mustafaen Kamal 2 and Jamien Dave 1. the other boys who took part were Mervin Mahenthran, Priyen Patel, Ashal Kansara and Akash Alexander. Thank you to all the people who came and a special mention of the pitch that was extremely bumpy and small, which we adapted to well.

**DEJI OLATUNJI** When you're not playing for your school B-team! LOL

 **OLAJIDE OLATUNJI** Likes **NANDO'S** 👍

 **JIDE OLATUNJI** checked in at **NANDO'S** with **YINKA OLATUNJI, DEJI OLATUNJI** and **OLAJIDE OLATUNJI**

# HOW NOT TO BE A TOOL ONLINE

Man, this chapter does not make pretty reading. It's like looking in a mirror, expecting to see an absolute legend, only to see a big spunking cock staring back. And you know what, we're all guilty of doing at least one of the things I'm gonna rage about in here. Goddamn guilty as charged.

Back in the day, when I was around 12 years old, I used to troll the hell out of forums. I would say some pretty bad things, to total randoms, hoping to get a reaction. I usually got one as well, with people threatening to find out where I lived and kill me. I thought it was hilarious. And if I wasn't trolling I was spamming, clogging up forums with total shit. I'd usually get banned but then I would just set up a new profile and do it all over again.

However, these days, as a victim of trolls myself, I now feel bad. I've experienced it from the other side – karma's a bitch, man! Still, at the time it was top jokes, and I suppose it kept me off the streets.

Anyway, if you've ever been a total tool online, or worried that you might be, then fasten your seat belt and join me on a journey of self-discovery, as I sift through the sewage of the online domain. Fuck, this isn't gonna be pretty!

# My Mom's Online Etiquette Guide

When I was growing up my mom was on my case all the time. 'JJ, why are your socks like cardboard?' and 'JJ, stop RKOing your brother from out of nowhere'. I couldn't do nothing without her in my earhole. But while it used to do my head in, I know now that she probably stopped me from becoming a total tool, rather than just a partial one ; )

But while moms can kick your ass in real life, social-media doesn't seem to apply the same rules. You see, when you're online you can be a prize tool without your mom finding out and whooping your ass. While that can be a good thing, sometimes we all need to listen to our moms, so I've roped in mine to see what she thinks about some common online stereotypes. They say moms know best, so over to you, Mom!

*Thank you, JJ. OK, this should be fun. Let's see what we have here . . .*

## THE OVERSHARER
*An individual who shares every single detail about their lives on social-media, no matter how trivial or embarrassing.*

I think these people just want to play a part in the world. They must be lonely to be constantly putting stuff out there, trying to get people's attention. But they need to be careful, as whatever they put online is there forever, and they don't want it to come back to haunt them in later life. And they also need to remember that some of the things they say might have an effect on their friends and family. I've had to tell JJ off numerous times for saying too much about certain things, such as drawing pictures of how he was conceived. If he really wants to know how it happened, all he has to do is ask and I'll give him the gory details!

## THE HUMBLEBRAGGER
*An individual whose posts appear humble but are in fact a shameless attempt to boast about their lives.*

I always tell my sons how important it is to be humble, but at the same time not to be ashamed of their success. If you're proud of what you have achieved, and want to share it with the world, go right ahead. Who knows, people might be inspired or even learn from it. But remember, no one likes a show-off, and trying too hard to appear humble is just another way of bragging. And if you really do want to show off, at least make it about something you can be proud of, like some charity work. I know my local old people's home is looking for volunteers to help out at bath time.

## THE KNOW-IT-ALL

*An individual who goes online looking for an argument and is never wrong.*

We all have friends who think they are never wrong. Whatever you say, they always have an answer, which they try to back up with supposed facts. And it seems like social-media is full of these sorts of people, who go online looking for an argument, and more often than not it's just an excuse to try to appear superior or to bully others. I tell my sons that it's important to fight for your beliefs, but you should listen to others' opinions as well. You don't need to go shouting your mouth off all the time. Let people respect you, and eventually they will ask you for your opinion. And if you do enjoy debating, why not join a debating society to learn the ropes? Who knows, it might be something you could put to good use in the future, rather than just arguing with others online.

## THE BREAKING NEWSER

*An individual who always has to be the first to break the latest news in an attempt to set themselves up as the authority on the subject.*

These people feel the need to be the first to post any big news, so that people will interact with them. That's fine, I suppose, as it is a way of starting a conversation, but again, you've got to be so careful what you post. There have been a few cases recently where social-media users have been sued for posting incorrect stories. A single tweet has cost them thousands of dollars. So, before you click 'submit', check that what you are posting is true. If being the first with the news is something that excites you, then why not look into working for your school's newsletter, or even starting a blog?

## THE VAGUEBOOKER

*An individual who posts vague statuses regarding their well-being, without ever revealing what is actually wrong, in order to get people to respond.*

This is really just attention-seeking, as by not telling the whole story in their status, these people are looking for someone to ask them a question so they can carry on talking about their issue. It is like going fishing. But I feel sorry for these people, as sometimes they are having a tough time, and are desperate to engage with others. My advice would be first to try to talk to your real friends, away from the computer, and only if you have no one to go to should you then go online. However, if you make a habit of being a Vaguebooker then sooner or later people are going to get fed up of you, and just like the boy who cried wolf, when you most need people they won't be there for you.

## THE SELFIE

*An individual who only posts selfies.*

Ah, yes. The Selfie. Everyone is posting selfies these days. I don't really have a problem with this, as I think they can be fun, but I draw the line at showing off too much flesh. I don't know why people feel the need to show that much of themselves, and it can also be dangerous, as there are a lot of strange people on the internet. If you do love taking pictures, why not join a photography class and learn just how inspiring photographs can be – not just the ones of you!

## THE OBSESSED PARENT/PET OWNER
*An individual who only updates their status to post pictures of their baby or pet.*

I think it's nice initially to see some pictures of babies or pets, but some people go too far and that is all they post. Don't overdo it. Mix your statuses up and show you have a life beyond your children and your pets. Give people a break! And if you do feel like you need to get out more then take up a hobby, like ballroom dancing, for instance, so you have something else to talk about.

## THE FOODIE
*An individual who posts pictures of every meal they eat.*

I really don't understand people who post pictures of everything they eat. I could understand if it was a really outstanding meal, but otherwise people just aren't interested. Have a good time, and just eat your food without feeling the need to photograph it. Besides, by the time you've taken the photo, added filters, and posted it online, your food will be cold. Every time you're tempted to take a photo of your food, just say grace instead, and be thankful for it.

## THE INVITER
*An individual who constantly invites their friends to play the latest online games.*

I get fed up of being invited to play Candy Crush by the same people. It's ok to send an invitation once, but if that person doesn't respond, or declines, then don't send it again. There is a reason they might not want to play these games so leave them alone. However, if you invite me over for a game of Bridge, and a cup of tea, I'm there!

# HASHTAGS THAT PROVE YOU'RE A #DICK

Hands up if you've used a hashtag before. Yup, just about everyone. They're a necessary evil in the social-media world and the first step to being a tool.

While some hashtags can be pretty damn funny, others are like scratching nails down a blackboard. So, here are some of the most overused hashtags that peeps need to take out to the back garden, shoot in the head and bury already. Sometimes you've gotta be cruel to be kind.

## # nofilter

AHHHHHH, MY EYES!!! Please, just use the goddamn filter! There is a reason God invented it.

## #yolo

Sure, we've all dropped a #yolo in our time. Guilty as charged. Lock me up and throw away the key. But c'mon, man, not every damn thing is a #yolo. I get it, it's meant to be ironic, and it was half-amusing the first time I saw it, but it's time to lock #yolo down.

## #blessed

Now, this is usually said when someone is trying to l humble but is actually boasting. FUCK THAT SHIT you're having a good time, just say so, man! Like, 'Chil with my bae, drinking champagne. Suck my dick, y'a

## #foodporn

Dude, you just posted a pic of someone vomming on a plate. Are you ok? Oh, it's meant to be food? And I'm meant to be envious of that pile of puke? LOLs. The only legit #foodporn in my world is Melanie Iglesias, naked, covered in KFC!

## # followme

Well, shit, it's in a hashtag, how can I turn down that opportunity? #blocked

# winning

Yup, you've won, alright. We can all see you're a prize melon. Now please remove yourself from my timeline.

# #sorrynotsorry

Excuse me? What are you actually trying to say? Are you sorry or not? And are you going to explain what you should be sorry about? For God's sake just say you're sorry already. Oh, you're not trying to say sorry. You're trying to make people jealous . . . #DICK!

# #selfie

o you've just posted a pic of your face and feel he need to let us know that it is actually a selfie. We get it. It's hardly a secret code. Just post your pic and move right along. Nothing to see here.

# #justsaying

WOOO! Check out the big balls on you, saying something controversial behind your computer, and making sure everyone knows you're a badass with a hashtag.

So, if you want to avoid looking like a tool these hashtags are now banned. No excuses. I don't want to see them in my timeline no more. This shit is done!

# swag

Remember the Harlem Shake? Yeah, that shit was funny . . . in 2013. Just like this hashtag.

# THE INSPIRATIONAL PAGE

Lord, please give me some goddamn strength! You don't even understand how pissed off I get looking at all the lame inspirational quotes that clog up my Instagram feed. Some people need to Man the Fuck Up and look closer to home if they need some inspiration.

Take my parents for instance. They both got off the boat from Nigeria, with hardly a penny to their name, when they were just 18. Soon they met each other, had sex without a condom and had me : ) With a pain-in-the-ass kid to feed they had to do loads of jobs to make ends meet, and they started saving as hard as they could. Soon they bought a few properties and rented them out, making themselves some decent cash in the process. So, from nothing, and with little help, they made a pretty cool life for us all. I gotta give them serious respect, man. That shit is proper inspirational.

However, if you are an Instagram tool, and really can't live without your inspiration being served on a filtered picture, with a famous quote, then this shit is legit.

## FIFA INSPIRATION

'Invincibility lies in the defence; the possibility of victory in the attack'
*Sun Tzu*

## KFC INSPIRATION

'Part of the secret to success in life is to eat what you like'
*Mark Twain*

## FITNESS INSPIRATION

'It is a shame for a man to grow old without seeing the beauty and strength of which his body is capable'
*Socrates*

## BLACK INSPIRATION

'Any color – so long
as it's black'
*Henry Ford*

## LITTLE BRO INSPIRATION

'The younger brother
must help pay for the
pleasures of the elder'
*Jane Austen*

## DAD INSPIRATION

'Becoming a Dad means
you have to become a
role model for your son.
Someone he can look up to'
*Wayne Rooney*

## DEAD NAN INSPIRATION

'Perfect love sometimes
does not come until the
first grandchild'
*Welsh proverb*

## MOM INSPIRATION

'Mothers are
all slightly insane'
*J.D. Salinger*

## WANKING INSPIRATION

'Pleasure and action make
the hours seem short'
*Shakespeare*

# OVERSHARING

We've all got that Facebook friend who just won't shut the fuck up about every single thing they are doing. Lord, give me some goddamn strength. These are real deal tools. And some people go beyond even that, telling the whole world about stuff most people wouldn't share even if they had a gun to their head.

But, y'know, I've done some pretty dark stuff in my time, and this seems like a good place to get it all off my chest, so forgive me Lord, it's time for me to join in and overshare . . .

## The Time My Brother Pissed on Me

So, one day we all went on a family trip. My brother was about seven, and I was, like, nine or ten, and we were sat in the back seat while my dad drove along the motorway.

Suddenly, my brother started to hold his dick and make a funny face. I asked him what was wrong. He told me he needed the toilet.

'Mom, Dad,' I said. 'Deji needs the toilet.'

'There's nowhere to stop,' my dad replied. 'He'll have to hold it.'

Ok. No big deal. But then Deji started to cross his legs and bite down hard on his lower lip, which, I have to admit, I found quite funny. In fact, I was secretly hoping he would piss his pants so I could hold it against him until his dying day. Even at that young age I knew that this could be a memorable moment.

'I'm not going to make it, Dad,' he said, and started to cry. 'Please! I'm not gonna make it.'

But my dad just continued to ignore him. Absolutely no mercy.

Now Deji had some tears rolling down his cheeks, and was squirming in his seat, making sounds I've never

heard a human being make before. Suddenly, I started to see that maybe this wasn't so funny. So, I shouted, 'Oi. Oi. He's going to blow. We need to stop.'

'He can hold it,' my dad snapped.

I looked at Deji. The kid was crawling up the wall. 'Help me, JJ. Help me!' he begged, like he had terminal cancer or something.

But my parents just kept ignoring him, even when he started to cry, 'I'M LEAKING! I'M LEAKING!'

Shit was getting serious. The kid was going to explode in his pants any second unless I took some action, so I grabbed an empty coke bottle and told him to piss in that.

'It won't fit, JJ,' he cried.

'What won't fit?'

'My willy won't fit in the bottle.'

And I was like, 'You're seven goddamn years old! You've barely even got a dick so just put it in the goddamn bottle already.'

Finally, he did as he was told and pulled out this little worm, which unsurprisingly fitted comfortably in the bottle. I looked away, not wanting to be a freak watching my brother piss, but I could hear he was

filling up the bottle fast, like he was an out-of-control garden hose. Glug. Glug. Glug. Now I started to panic that he was going to fill up the bottle and then what? Piss all over the car? Fuck, no! Not on my watch! So, I turned around to manage the situation, but as I turned I saw the bottle slip from his grasp. Oh, shit! Everything suddenly went in slow motion. Sprays of yellow liquid started to spiral towards me . . .

NOOOOOOO!!!!!!

BOOM! Piss went absolutely everywhere, and he was still going, like a sprinkler, gushing it all over the car.

I started screaming. 'HELP!!! HELP!!!' I was treating the piss like it was acidic liquid and it was burning my limbs. All the while Deji kept on pissing and crying.

Finally, with mayhem engulfing the back seat my dad looked at me and shouted, 'JJ, WHY DIDN'T YOU TELL ME HE WAS SERIOUS? WE COULD HAVE JUST STOPPED AND LET HIM GO ON THE SIDE?'

I was like, are you for real? Really for real? Fuck man, my brother was still pissing on me and he was bawling me out. Not cool! But instead I just shrugged my piss-covered shoulders and took it like a pussy.

So, yeah, that was the time my brother pissed on me. What a little prick!

79

# MY TOP FAN MEMES

While we might be focusing on how not to be a tool right now, sometimes being a tool is A-OK. Let me explain. You probably think I haven't noticed, but I know a lot of you are commenting on my Facebook posts just to try to get top comment. And, to be honest, while some of the shit you post is very disturbing, some of you guys are funny as fuck! Seriously, sometimes I post stuff just so I can see what crazy shit you can come up with.

Although some of the stuff you have laid down is too fucked up, some of it is just about book-worthy. So, for our sheer entertainment, I've put together some of the most popular memes to my Facebook posts, as well as a few of my favorites. Fellow tools, I salute you!

George Wise

THEY SAY YOU ARE WHAT YOU EAT... BUT I DON'T REMEMBER EATING A FUCKING LEGEND

Adam Belsey

WHEN YOU BEAT YOUR FRIEND IN FIFA

IN FRONT OF YOUR OTHER FRIEND

Ahmet Celik

LUNCH BREAK BOOT OF CHOICE

97 - SHOT POWER
93 - ACCURACY
95 - CURVE
91 - LONG SHOTS
99 - ONE ON ONES

Iliesa Vai Dakuwaqa

My Graduation Speech

"I want to thank Google, Wikipedia, and whoever the hell invented copy and paste. Thank you."

Ayman Al-Shemmari

WHEN YOU WALK BACK INTO CLASS

AFTER HAVING BEEN SENT OUT

Robert Jr Richardson

Please donate a spoon to JJ

Azzam Jamil

If you crush a marshmallow bunny it looks like Kim Jong-Un

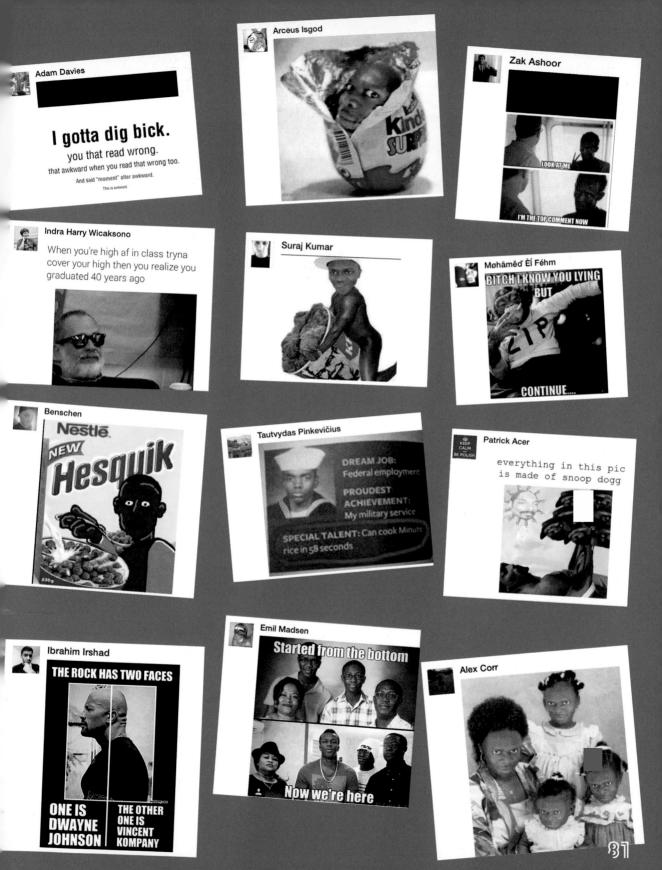

# THE TOOL HALL OF SHAME

It's a weird thing. I look like a normal, regular guy, yet deep down I'm a tool. But just from looking at me, how would anyone know that I'm inflicted with such a disease? And the same goes for you guys. I'm sure I've got loads of tools as fans, but how can anyone work this shit out when you do such a good job of hiding it?

Now that I've come balls out, and admitted on the front of a fucking book that I'm a tool, I thought this might be a good opportunity for you guys to join me. I invited all of my fans to send me pictures of them admitting they're tools, so that I could put together this essential list. If your photo is here then welcome to the club!

Note: These are all pics of my British fans where my book has a proper title. If you don't know what a bellend is, go ahead and look it up!

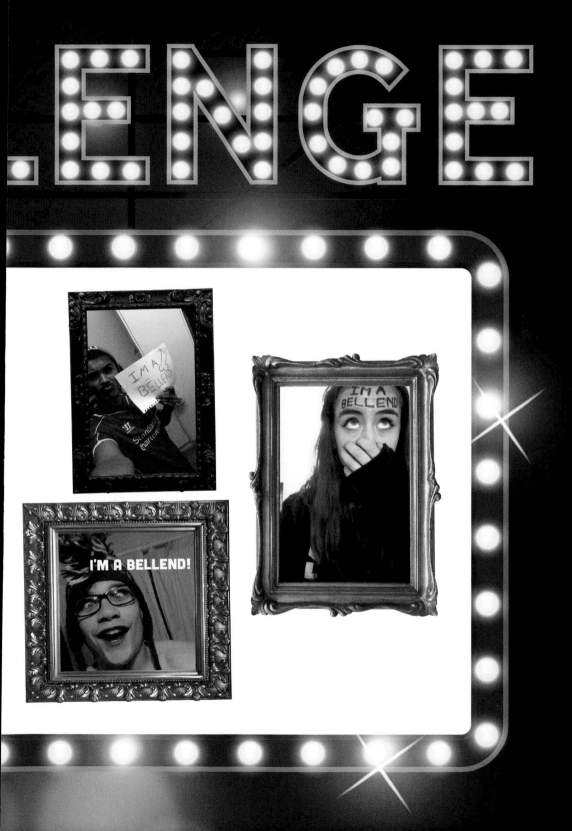

# KSIBOOK

## OLAJIDE OLATUNJI
born on 19 June 1993

Timeline | Videos | Photos

📍 **OLAJIDE OLATUNJI** checked in at
**BERKHAMSTEAD INDEPENDENT SCHOOL**

 **OLAJIDE OLATUNJI** Check me out rocking Moby Dick as Hook Hand Henry tonight!

 **OLAJIDE OLATUNJI** Fuck! I can't believe we've sold Thierry Henry to Barca : (

**OLAJIDE OLATUNJI** Anyone been on this YouTube thing? It's madness!

**OLAJIDE OLATUNJI** Check out **HJERPSETH** on **YouTube.** He's got some sick FIFA vids!

**Head of House Report**

I am pleased to see that JJ has worked better in some of his classes and improved his grades, especially in Business Studies, History and Religious Studies. However, a lack of concentration and immaturity, still remain an issue in some of his subjects. He must put a lot more effort into Spanish, as Mrs Moss reports that he is still not taking the subject seriously.

JJ represented the School in the U15C football side and participated in the inter-house football and swimming competitions this term. He also continued to participate in the Duke of Edinburgh Award Scheme.

I look forward to some harder work from JJ next term.

**OLAJIDE OLATUNJI**
Me, immature? LOL

**OLAJIDE OLATUNJI** Absolutely blowing up **FIFA 07** right now! Highest ranked PS player in the world! If only you could get paid for this shit : /

**OLAJIDE OLATUNJI** is gay

**YINKA OLATUNJI** Just to let you know that me and your father always suspected this and we support you. Nan and Grandad do to. Is Simon your boyfriend? He's cute ; )

**OLAJIDE OLATUNJI** I'm gonna kill whoever did this!!!!

**DEJI OLATUNJI** ; )

# GAMING

Fuck, I need a break from being a tool for just five minutes before I shoot myself in the face. And what better way to chill than to chat shit about FIFA? Man, that game is such a major part of my life, and it seriously pisses me off when EA fuck with it.

My love affair with FIFA started way back in 2000, when I was just seven years old. Back then I really didn't know shit about computer games, but one day my dad brought home some games for me to play and FIFA 2000 was one of them. I gotta admit, I wasn't really into soccer at the time, so when he presented me with it I was like, what the fuck is this shit?!

But oh, man, did that game change my life. Whenever my parents weren't hogging the TV watching *Murder She Wrote*, I would be hooking up my PlayStation and getting down with my favorite team, Arsenal. In fact, I probably ended up supporting Arsenal in real life because they had such a sick team on FIFA at the time, with the likes of Bergkamp, Henry, Vieira, Pires and Ljungberg ripping shit up.

As you know, this obsession with FIFA led to me posting videos on YouTube, with millions of people now watching, which is pretty crazy as back in the day everyone used to tell me that playing computer games was a total waste of time. Just goes to show ; )

So, while we are taking a well-deserved time out from being tools, I'm gonna give you guys some badass tips on how you can join me in the pantheon of FIFA legends, and I might even have a few suggestions for how the guys at EA can Man the Fuck Up and make the greatest game in the world even better.

# HOW TO TELL IF YOU'RE A GAMER

*Hey, KSI, how can I tell if I might like computer games?*

It's a valid question. Playing computer games isn't for everyone. And why spend hours of your life trying something you might not enjoy? Fuck, you might as well just spend that time wanking! So, let's just dive on in there and see if you have the potential to be the next big gamer . . .

Do you rage when you lose?

Do you really like winning at absolutely everything?

Do you like killing people in the worst ways imaginable?

Do you hate showers?

# KSI's FIFA Commandments

Winning at FIFA might just be the best feeling in the world, especially when you score a last-minute sweaty goal. Ah, man, just the thought of it makes me smile. But some games are just too damn big to let your FIFA skills alone do the talking. Sometimes you need to do anything you can to get an edge, otherwise your mate is going to get up in your grill, giving it the big one, and we just can't allow that to happen. Am I right?

So, listen up. These commandments will either freak your opponent da fuq out, or disrupt their concentration for long enough for you to score a goal.

### Thou must slap thy opponent when they are on the attack

### Thou musteth pull downeth thy pants in the middle of the game

### Thou shouldeth playeth naked (guaranteed winner if thy are a girl)

### Thou must loseth thy shit over everything

Thou should placeth a KFC bucket on thy table, openeth thy lid, and useth a fan to bloweth the smell towards thy opponent (especially effective on vegetarians!)

Thou should tell thy opponent thou desireth sexual relations with thy opponent's sister and/or mother in explicit detail. To really go to extremes, I recommend throwing thy opponent's father into the mix as well

Thou should excrete bodily gas and waft towards thy opponent

Thou should secretly replace thy opponent's best player with Emile Heskey before thou play

HESKEY

Thou should haveth an undesirable ringtone and let thy phone ringeth repeatedly

Thou should commentate in the voice of world's most boring soccer commentator, Alan Smith

So now you're the big, bad boss of FIFA, lording it over your loser mates, you might want to think of throwing something else into the mix: a forfeit for the loser. I once kicked fellow YouTuber Jo Weller's ass so bad he had to down Tabasco sauce. It was hilarious, but I felt bad for him so I tried it myself. Man, that shit is HOT!!!

Anyway, as I like to help out whenever there are some serious LOLs at stake, here are some commandments for the losers to abide by. And remember, the shame is doubled when you get to film their loser ass and post it all over social-media!

### Thou must alloweth thy winner to scriketh thou with a wet fish

### Thou must alloweth thy winner to RKO thou from out of nowhere

### Thou must giveth thy winner access to thy facebook for five minutes

*/*/*

### Thou must Instagram thy bare nutsack

## Thou must siteth in an ice bath for one minute

## Thou must eateth a ghost chilli

## Thou must streaketh down thy street

## Thou must allow thy victorious winner to cut thy hair

## Thou must stoppeth a random and explain how thou loseth the game

## Thou must smell thy pet's butthole

So there you have it. You're not only a FIFA champ but you can also revel in your mates looking like prime-time dick nuggets. Enjoy!

# PIMPING UP FIFA

Man, I love FIFA, even though it can sometimes be a fucking pile of horseshit! But every now and again I start to wonder if we can't take FIFA to the next level and truly annihilate the competition. So here are some additions I feel could make the greatest game ever, even better . . . Americans, google this shit.

## 1 THE WEALDSTONE RAIDER

This funny-looking dude went viral big time in 2014 when he kicked off at a non-league game, fronting up to some opposition fans, with the gangsta line, 'Do you want some? If you want some I'll give it ya!' I say get The Raider into the stands so he can cause some proper mayhem. In fact, fuck it – let us actually control The Raider, ha ha.

## 2 EVA CARNEIRO

DAMN! This beauty is Eva Carneiro, Chelsea's first-team physio. I don't know the stats but I'm pretty sure there has been an increase in groin strains since she joined the club. John Terry, I'm looking at you! So, next time one of your players gets injured on FIFA, and you want to throw your controller against the wall, seeing Eva race onto the field would definitely chill you out. Besides, it would be nice to see more females in FIFA.

## 3 GEOFF SHREEVES

I love Shreevesy. This guy's banter is top notch. Remember when he made Ivanovic cry after telling him he was suspended from the Champions League Final? Man, that made me laugh. So imagine having control of your very own Shreevesy! Picture the scene: you've just demolished your mate on FIFA, and then you get to interview his star player about just why they're so shit. Gold dust!

## 4 HALF-TIME CELEBRITY FIELD APPEARANCES

A half-time celebrity field appearance can liven up any game. Who can forget Michael Jackson rocking up at Exeter City or Sly Stallone at Everton? Let's get a list of celebs on FIFA so that you can parade them at half-time. Shotgun Drake!

## 5 CHANTS

Soccer fans are funny bastards, and over the years they've come up with some priceless chants to either encourage their team or demoralise the opposition. Who can forget West Ham fans singing to Liverpool fans, 'WE'VE GOT DI CANIO, YOU'VE GOT OUR STEREOS,' or 'YOUR TEETH ARE OFFSIDE, YOUR TEETH ARE OFFSIDE, LUIS SUAREZ, YOUR TEETH ARE OFFSIDE.' This need to be on FIFA, pronto.

## 6 NIGHTCLUBS

On the field, FIFA is as close as many of us are going to get to professional soccer. So why doesn't FIFA let us have the off-field experience as well? After a game your typical Premier League soccerer likes nothing more than a few bottles of Cristal in a roped-off VIP area, surrounded by hot ladies. Surely it's not too much to ask for FIFA to have nightclub mode?

### 7 CHEERLEADERS

When I asked my boys, 'What's the one thing you would add to FIFA to improve it?' most of them said, without even thinking, 'Hot girls.' I'm certainly not going to argue with them, so let's get some cheerleaders on there.

### 8 BE THE REF

Your two mates are playing an epic FIFA game to settle a few scores. Everything is riding on it. Money, pride and glory. And you're controlling the referee! Fuck, yes. I would be such a twat as a ref. It would be amazing.

### 9 MESSAGES

I show off my underwear waistband all the time. It's no big deal. Sure, my mom might say, 'JJ, pull dem bleeding trousers up,' but that's as far as it goes. However, when Danish striker Nicklas Bendtner lifted up his shirt in Euro 2012 to reveal Paddy Power branded boxer shorts, UEFA fined him £80,000! Chin up, mate. But wouldn't it be great if you could write messages on your players' T-shirts, which they could reveal after they scored such as 'Your mom has my number Simon ;)!' Brilliant.

### 10 BETTING

Soccer and betting have become synonymous with each other in recent years. And I should know, I've lost a fortune! Still, imagine being able to bet on yourself, or your mates, online while you play. The stakes just went up a notch.

### 11 STREAKERS

Damn, this would be great. Sometimes you can get bogged down in a boring game so what better way to liven it up than by controlling a streaker, with your opponent controlling the official trying to chase you down. This could be a whole game in itself! EA, call me! We need to talk!

### 12 LINEKER MODE

Gary Lineker looks a smooth customer on *Match of the Day*, but did you know the England legend actually shit his pants when playing for England in the 1990 World Cup? Serious! So, in honor of England's second-highest all-time goalscorer, your players should definitely be able to unload their bowels onto the field.

95

# KSI'S FIFA TREASURE HUNTER

Sometimes you can find treasure in the most unusual places. Take Tinder for instance: it's full of some of the most warped mutants to roam this earth, but every hundred or so swipes you might just stumble across pure gold. And the same applies to FIFA.

Now, in an ideal world all of our FIFA teams would have Ronaldo and Messi in them. Sadly, there aren't enough of those bad-boys to go around; plus, they're super overpriced. So, to get one up on your mates, you need to sift through a lot of crap to find a few nuggets of gold. I know, it sounds like hard-ass work, but Chill the Fuck Out, I've done it for you. I've waded through the stats of some god-awful players to see if anyone might have been overlooked. And it turns out that if you put in the work there are some proper ballers among the trash.

1

2

3

4

5

6

7

8

9

10

## 1 Victor Ibarbo
### Roma

In 111 games for his previous club Cagliari, Ibarbo banged in 14 goals. Decent for a defender, but this dude is meant to be a forward! Now at Roma, things haven't gone much better. But hold the fuck on now, in FIFA this guy's Speed, Acceleration, Ball Control and Skill stats are right up there with the best. How did this happen? Fuck knows, but Ibarbo is definitely one of FIFA's hidden gems.

## 2 Mario Balotelli
### Liverpool

Man, where did it all go wrong for Super Mario? This guy was a beast until he signed for Liverpool. But, while's he's been stinking the joint out in real life, his stats on FIFA are still very respectable, and if you need someone to knock in a penalty then Mario is definitely your boy.

## 3 Mauro Zarate
### West Ham

Who? It's a fair comment. Since signing for West Ham, Zarate has barely featured, and then when he was sent to QPR on loan they tried to send him back after three weeks. Cold! But wait a minute now, this dude was top scorer in Argentina before going to the Hammers, and he had a pretty decent record in Serie A as well. With impressive Ball Control, Agility and Sprinting stats, Zarate is well worth a look if you're having trouble opening up defenses.

## 4 Nani
### Manchester United (Sporting Lisbon)

LOLs. Nice one, KSI. Nani is shit! That seems to be the common perception among most fans, but I always thought Nani was pretty sick, and so does FIFA. With stats like 92% for Agility, 87% for Ball Control and Dribbling, and 85% for Shot Power, Nani is good enough to grace any FIFA team.

## 5 Matt Jarvis
### West Ham

FIFA gives West Ham's forgotten man, Matt Jarvis, 93% for Balance, not to mention some pretty high stats for Crossing, Acceleration and Sprint Speed. Not bad at all for a bench warmer.

## 6 Seydou Doumbia
### Roma

Ok, confession time. Doumbia is not shit. Far from it: 62 goals in 109 games for CSKA Moscow proves that. But how many people have actually heard of him? Not that many. And in FIFA, Doumbia is a proper baller. Check out these stats: Acceleration 91%, Sprint Speed 94%, Stamina 94%. Forget some of your bigger names and sign up Doumbia pronto. This dude is solid gold.

## 7 Jonathan Biabiany
### Parma

Another hidden gem from Italy. Sure, Biabiany was decent enough for Parma, but his FIFA stats elevate him to another level altogether. For instance, 97% for his Sprint Speed stat. This guy is absolutely rapid!

## 8 Nedum Onuoha
### QPR

QPR are shit. They consistently stink up the Premier League and you've got to be truly appalling not to make their first team. But while Nedum Onuoha is getting splinters in his ass most weeks, he's actually not bad on FIFA. Sure, he's not big balling, but 89% Sprint Speed is nothing to be sniffed at.

## 9 Bernard
### Shakhtar Donetsk

Who can forget Brazil getting their pants pulled down by Germany in the World Cup semi-final, when they lost 7–1? That was probably one of the worst performances of all time, and that Brazil team weren't great in the rest of the tournament either. But let's not be too hasty here. You'd probably only pick Neymar out of that Brazil team, right? Well, think again. With Acceleration, Agility, Balance and Sprint Speed stats all well into the 90s, Bernard is a FIFA genius.

## 10 Welliton
### Mersin Idman Yurdu

Who da fuq is Mersin Idman Yurdu? I gotta admit, I don't know, and you'd think anyone playing for them would suck some serious ass. Well, Welliton isn't half bad and has some decent pedigree, having finished as top scorer in the Russian league twice before moving on from Spartak Moscow. Sure, he's no Messi, but who is?

# KSI'S BAD-BOY XI

Every team needs a bad-boy, and I suppose back in the day I was the one on my school team. It wasn't that I was necessarily hard, and would be smashing into tackles or anything like that, but I used to just sit back in defence and trash talk everyone. My main goal in the game was to piss the opposition's striker off so much that he would snap and get sent off. I would be in his ear all game and then if he so much as touched me I would dive on the floor, screaming for my life. Yup, even at soccer I was a tool, but it usually worked, and I have to admit, it was funny as fuck!

But can you imagine if we had a whole team of bad boys on FIFA? That would be more frightening than a dose of herpes and you'd soon have the opposition begging for mercy. So, I gave this some serious thought, and put together a pretty badass team.

## GOALKEEPER
### PADDY KENNY

Man, this dude's man-boobs used to give me nightmares. Seriously, this guy could feed a herd of goats with them nipples. And he kinda looks like he would enjoy it . . . Anyway, anyway, I digress. Old Kenny makes the list not through his cheeseburger eating ability (which is probably EPIC), but because when the silly sausage was at Sheffield United he missed a drugs test and was banned for nine months. He was then ALLEGEDLY released from Leeds United in 2014 for being too fat, or because he offended the owner's superstitions by being born on the 17th day of the month.  Either way, it was a dark day for McDonald's in Yorkshire.

## LEFT-BACK
### BEN THATCHER

BOOM! Eat my elbow! This guy perfected the art of take no prisoners. I mean, have you seen his flying elbow on Portsmouth's Pedro Mendes? It almost took the dude's head clean off, which resulted in Pedro spending the night in hospital and Ben being banned for eight games. Now retired, surely the UFC has to give this guy a call?

## CENTRE-BACK
## JOHN TERRY

Hate to admit it as an Arsenal fan but John Terry is a world-class defender who always comes up with the goods in the box. But in real life that's not the only box this dude 'comes' in, as his former team-mate Wayne Bridge knows only too well, after finding his captain had been banging his girlfriend. And if John isn't slipping it to his teammate's girlfriend, he's apparently using racially insulting language to his black opponent. Still, while you might not want to let this guy hang around your bae, he does a damn good job in FIFA.

## CENTRE-BACK
## CHRIS MORGAN

As an Arsenal fan, I gotta lot of time for this dude. After all, he once punched Robin van Persie. Massive respect. But SHEEZUS, have you seen what he did to Iain Hume, after he swung an elbow at him? Fuck, no! NO! NO! NO!

## RIGHT-BACK
## PHIL BARDSLEY

Biggie Smalls once said, 'Mo Money, mo Problems', something Phil Bardsley learnt the hard way after being photographed covered in £50 notes after a successful visit to a casino. This seemingly innocent picture led to then manager Paulo Di Canio banning him from the Sunderland team. Things then got worse for Phil when Sunderland lost to Fulham on the opening day of the season, and he posted, 'Great opening day ha ha ha ha ha ha ha ha' on his Instagram account. Mans don't play for Sunderland no more. LOL!

## CENTRE MIDFIELD
## STIG TOFTING

Usually, when mans don't like the music they are playing in a restaurant, mans will either ignore it, or go elsewhere. Shit, to be honest, mans just wants to eat that juicy fried chicken. But Stig don't play like that. Like in 2002, when Stig head-butted a restaurant manager, and then attacked the chef, because he didn't appreciate the Danish tunes they were blasting. Still, when you consider that aged 13 he saw his father murder his mother before shooting himself, this dude has every right to be a bit on edge. And Danish music probably is really shitty.

## CENTRE MIDFIELD
## VINNIE JONES

There ain't a lot a man can do in four seconds. Maybe have a wank, or eat a KFC wing. But Vinnie Jones was actually booked within that time, earning himself the fastest yellow card in history. He followed that up with regular suspensions and trips to the FA, to which he proudly said, 'I've taken violence from the terraces and onto the field.' He now earns his living playing bad-boy gangsters in movies. Don't mess. This guy is nails!

## LEFT MIDFIELD
## RYAN GIGGS

It turns out that playing for Manchester United, winning trophies and having your pick of the ladies just isn't enough for some people, as Rhodri Giggs found out in 2012 when his superstar brother admitted to an eight-year affair with his wife. I guess Giggsy took the phrase 'keep it in the family' literally . . .

## RIGHT MIDFIELD
## CRAIG BELLAMY

In my limited experience of playing golf I know that when your shot is about to hit someone, you're meant to shout 'FORE!!!!' However, when Craig Bellamy decided to whack teammate Jon Arne-Riise with a golf club after he refused to join in a karaoke session, he quite simply forgot this golden rule and apparently shouted, 'Take that you ginger cunt'.

## CENTER-FORWARD
## ERIC CANTONA

Cantona had mad skillz, but the fact that he actually seemed mad must have helped a bit. Not content with being sent off against Crystal Palace in 1995, he then decided to flying kick a fan in the face as he walked off the field like a bona fide gangster. And if no one thought the Frenchman was barking already, then they certainly did afterwards when, in a press conference, he uttered the bat-shit crazy line, 'When the seagulls follow the trawler it is because they think sardines will be dropped into the sea.' Right . . .

## CENTRE-FORWARD
## DUNCAN FERGUSON

Deep down, we know most soccer players are pussies. If any of them tried to be a hard man off the field they would get their ass whipped. But not Duncan Ferguson. This man is actually terrifying. Back in 1995, this lunatic even received a three-month prison sentence for head-butting Raith Rovers' John McStay during a game. Don't mess!

# FIFA SCOUTING

Staying ahead of the game is one of the keys to being a top FIFA player, so you need to know where you can unearth talent that no one else has clocked yet. It's kinda like finding a hot chick on Tinder before everyone hits them up. So, I've done my research, and these bad-boys are definitely ones to keep on your radar, as pretty soon they are gonna blow up big-time. Just make sure you're first in the line!

## ANGEL CORREA

Although still only 19, Correa has been promising to explode, like a cock that hasn't been wanked, for a good time now. Likened to Sergio Aguero, he signed for Atletico Madrid in June 2014, only to have to take six months away from the game due to a heart tumor. Poor fucker :( But thankfully this dude was back in action in early 2015, and was the outstanding player in the Under-20 South American Championship. Just sit back and watch this guy rise to the top.

**KSI SCOUTING**

EXPLODER

**1**

Promising

**Angel Correa**
**Argentina**

**KSI SCOUTING**

RECORD BREAKER

**2**

Barca Bound

**Gabriel**
**Brazil**

## GABRIEL

When someone is labelled the next Neymar you gotta take notice. And the comparisons to the Barca baller don't end with a shit haircut. You see, Gabriel currently plays for Neymar's old club, Santos, where he has been banging in goals for fun, shattering records in the process. Word on the street is that Barcelona already have first option on the kid, so expect to see him in tandem with Neymar soon.

## WILL HUGHES

I know what you're thinking: ain't no way this kid is a baller. He looks more like Draco Malfoy. And the name 'Will Hughes' hardly screams world class skillzter. But steady the fuck on now, 'cause for a good few years this pale, skinny, skill monkey has been merking opponents off in the Championship, making over 100 appearances for Derby County. Still only 20, there's no way my boy Hughes ain't gonna make his mark in the Premier League.

**KSI SCOUTING**

BEWARE HARRY POTTER

**3**

Skill Monkey

**Will Hughes**
**England**

**KSI SCOUTING**

LOST A BET

**4**

Daddy's Boy

**Giovanni Simeone**
**Argentina**

## GIOVANNI SIMEONE

Whoa! Hold the Fuck On. This kid lost a bet, right? Apparently not. He just likes rocking a really shit haircut. But let's not be too hasty. He's the son of badass Atlético Madrid manager Diego Simeone, and finished as the top scorer in the 2015 Under-20 South American Championship, gobbling up nine goals. Currently with River Plate, it's only a matter of time before he moves to Europe and gets himself a decent hair cut. Despite that shit on his head, I still bet he gets all the girls! Fucking soccer players!

## JORDAN IBE

After absolutely ripping it up while on loan at Derby County, Brendan Rodgers couldn't get Ibe back to Anfield quick enough, where he continued to rip the piss. Lightning quick, and with a locker jam-packed with skills, there isn't any doubt that he's going to be a strong FIFA player for years to come.

KSI SCOUTING

RIPS THE PISS

5

Lightning

Jordan Ibe
England

KSI SCOUTING

DUTCH CAP

6

Blondy

Davy Klaassen
Holland

## DAVY KLAASSEN

Blond, Dutch, and Ajax's No.10, it's no surprise that Klaassen has been likened in style to one of my favorite players of all time, Dennis Bergkamp. With a hat-trick to his name already, as well as a full Dutch cap, it's only a matter of time before Arsene Wenger snaps him up. Hint hint, Arsene!

## RYAN GAULD

Just 19, this Scottish dude has already moved from Dundee United to Sporting Lisbon, where he is said to have a release clause of 65 million dollars. If that wasn't enough, he's already broken into the first team, and has earned a few Man of the Match awards playing as an attacking midfielder. This kid is 100% baller.

KSI SCOUTING

100% BALLER

7

Scots skills

Ryan Gauld
Scotland

## ALEN HALILOVIC

Barcelona have been rolling top players off the production line for years, and this little magician is apparently the next big one coming through. With seven caps for Croatia to his name already, the word on the street is that Halilovic is the next Luka Modric in the making.

**KSI SCOUTING**

MAGICIAN

Next Luka

Alen Halilovic
Croatia

**KSI SCOUTING**

LUCKY NO.7

Pubes yet?

Max Meyer
Germany

## MAX MEYER

Look at this kid! He looks barely old enough to have pubes, but he's already been capped by Germany, turned down a $23 million move to Chelsea, and inherited Raul's No.7 shirt at Schalke – all before he turned 19. The sky's the limit for this one. He's gonna blow shit up big time!

## MARTIN ODEGAARD

Youngest player to play in the Norwegian league? Check. Youngest player to score in the Norwegian league? Check. Youngest player to represent Norway? Check. Youngest player to play in the European Championships? Check. And now playing for Real Madrid, all before he turned 16. Dayum! Bet he still can't bench press like Akinfenwa though.

**KSI SCOUTING**

TOO YOUNG

Dayum good

Martin Odegaard
Norway

# FIFA FRANKENSTEIN

Sure, it's all fun and games being able to pick a team of the world's best players on FIFA, but what if you could put together the ultimate player? That would be sick and should definitely be an option in the game. But seeing as it's not, I gave it a go like Dr Frankenstein, and here is what this total baller might look like.

## HAIR
Djibril Cisse has had some pretty mental haircuts in his time and this one isn't half bad.

## EARS
Has any soccer got bigger ears than Gareth Bale? Anyway, he's a top player so they must be good for something.

## FOREHEAD
Ronaldo is unreal in the air so the forehead definitely has to be his.

## NOSE
Heskey has to make an appearance somewhere. So probably best to give him the nose so he can't do any harm.

## ARMS
Raheem Sterling is lightning, and I think it's all down to his little T-Rex arms. Seriously, check them out!

## MOUTH
I know, John Terry is a bit of a dick, but on the field he's a boss, so we definitely need his mouth.

## BODY
BEAST!!!! My boy Ade Akinfenwa may be playing in League Two right now, but he's still the strongest mo-fo in the game.

## LEGS
Jonathan Biabiany is one of the quickest players in FIFA so it goes without saying that we need his legs.

## FEET
Who else but Messi? This needs no explanation.

## UNIFORM
Lyon's third jersey from 2010/11 is my favorite uniform of all time. If anyone knows where I can get it, hit me up!

Alright then, let's see what this handsome son of a bitch looks like . . .

WTF is this piece of shit??? Man, this playa might have some total skillz, but he ain't gonna be a hit with the ladies.

# THE SICKEST COMPUTER GAME OF ALL TIME

Yes! This is what I'm talking about. The sickest computer game of all time, designed by moi. This is huge so, please join me on a magical journey into my completely fucked-up imagination and see what we can come up with.

## THE HERO

If it's my game then I've got to be the hero. And obviously I've got to have a big dick that I can use to hit people with, or blow them away with my explosive spunk.

## THE CONCEPT

Pretty much just like FIFA, apart from my opponents are a team of flesh-eating bad-boy zombies who I can attack with the super powers of my dick. However, this shit is hard damn work, so whenever I need some energy I've got to 'power up' by gobbling up some KFC chicken that is left lying around the field.

## AIM OF THE GAME

So, there's me and my big dick, and we are playing soccer against zombies while eating KFC – what next? Why not score a goal and rescue the smoking hot Melanie Iglesias? I need to have a hot girl in this game somewhere.

## ESCAPE

Once I've rescued Melanie I obviously need to take her somewhere private so we can get it on, but I'm trapped in a stadium full of zombies with the fans starting to invade the field. Fuck! Even my dick can't cope with this! No worries. I've added a monster truck into the game so I can hop in and mow down all those fuckwits.

## THE GOAL

I've killed all the zombies, scored a goal, eaten some KFC, rescued Melanie Iglesias, and driven a monster truck. Decent. I'd say a hero like myself deserves a reward, so after all that I'm allowed to access 'Get it On' mode. I think you can imagine the rest . . .

# CHALLENGE

## NAME THE GAME

Think you're shit-hot on games? Then let's put you to the test. All you gotta do is name the game based on the emoticons. Answers are below. Prepare to melt your brain!

1. ⚽ 16

2. 😇

3. ☎ of 🍩 ty: 👻 s

4. 👵 d 👍 eft 🚗

5. 🫏 a 😈 s C 💲

6. ⛏ C 🛶

7. 🦇 le 🏞

8. 🔴 😀 😮

9. 🦈 al 🌀 ta 🌊

10. 🎆 🧍 💃 ends

## YOUTUBE

**@MxZ634Gamer Was it hard for you to get noticed at first on YouTube, and if so how did you get noticed?**

It took me, like, two years to get noticed. You've just got to keep at it and get in with the crowd. For example, if you're doing FIFA videos, get in with that community and know who all the top dogs are. Getting endorsed by the top dogs makes a huge difference. And no one can say shit if you're making good videos, so that's gotta be your number one priority. At the end of the day, if you're banging out great content you'll eventually get the recognition you deserve.

**@LFCKYLE12 When did you realise you were doing well on YouTube?**

I suppose it was when I started getting good viewing figures. Back when I started, 20,000 views was mad, 100,000 views was unreal and 1 million views was almost unheard of. You'd never see a FIFA video get anywhere near a million views. When I got 50,000 views for the first time I lost my mind, I was so excited. If I got that now I would freak da fuq out! The way it's going, in five years' time, some YouTubers will be bummed if they get less than a million views per video. Man, who knows, some day YouTubers might be getting 1 billion views per video if this shit keeps on growing.

**@_MiCHERT_ What separates you from the rest of the FIFA YouTube community?**

I guess I just don't really give a fuck. I'm probably the only one who gives EA legit shit to its face. It's hard to differentiate yourself being a FIFA YouTuber these days. Back when I started out no one really did proper editing, or funny videos, but now YouTube is full of them. That's why I've started to concentrate on other things, like music, acting and doing books. The FIFA thing has become too saturated. I want to move on and try new things. There are only so many angles you can do on FIFA as EA don't ever really change the game.

**@Moin66465 How much time does it take for you to record, edit, and upload your videos?**

It depends on the video, but for FIFA it takes around 30 minutes to record, an hour to edit, and then another 30 minutes or so to add commentary. To then render it, and actually get it live on YouTube, will probably take another half an hour. So I guess, on average, it takes around two-and-a-half hours.

**@danyulfrost What's the worst thing about being a YouTuber?**

Probably the shitty fucking haters that I get, but other than that it's chill.

**@LOLMEPOO Favourite YouTuber apart from yourself?**

Ohhhhhh . . . probably SxePhil, real name Philip DeFranco.

**@TTAYW3210 If you weren't doing YouTube what type of work would you be doing?**

Probably homeless on the streets, sucking dick for money.

## FIFA

**@Alex_littleweg What would you do if you owned EA?**

Ah, man, I would just close that shit down!!!

# KSIBOOK

## OLAJIDE OLATUNJI
born on 19 June 1993

Timeline | Videos | Photos

 **YINKA OLATUNJI** Congratulations to my son **OLAJIDE OLATUNJI** for passing his Grade 5 saxophone exams.

**DEJI OLATUNJI** All that blowing practice will come in good someday ; )

 **SIMON MINTER** What was that rap you did in physics today?

**OLAJIDE OLATUNJI** HA HA! 'Oh yeaaaah I need a current or a voltage, I need resistance to slow down my average, 'cause I'm killing this rap, no bitch don't call me whack, or I'll slap you with my big dirty sack!'

**SIMON MINTER** LOL!!! Why were you playing a FIFA video on the projector when you were rapping about physics???

**OLAJIDE OLATUNJI** Why not? ; )

**OLAJIDE OLATUNJI** Likes **FRAPS** 👍

**OLAJIDE OLATUNJI** Likes **THAI LADYBOYS** 👍

**OLAJIDE OLATUNJI** DA FUQ!!!!
Who hacked my Facebook??

**DEJI OLATUNJI** ; )

**OLAJIDE OLATUNJI** Passed final exams

**SIMON MINTER** Nerd!

**JIDE OLATUNJI** Likes **BUSH AFRICAN BABES** 👍

**OLAJIDE OLATUNJI** Dad!
You do know everyone can see all of the pages you like don't you!!!!???

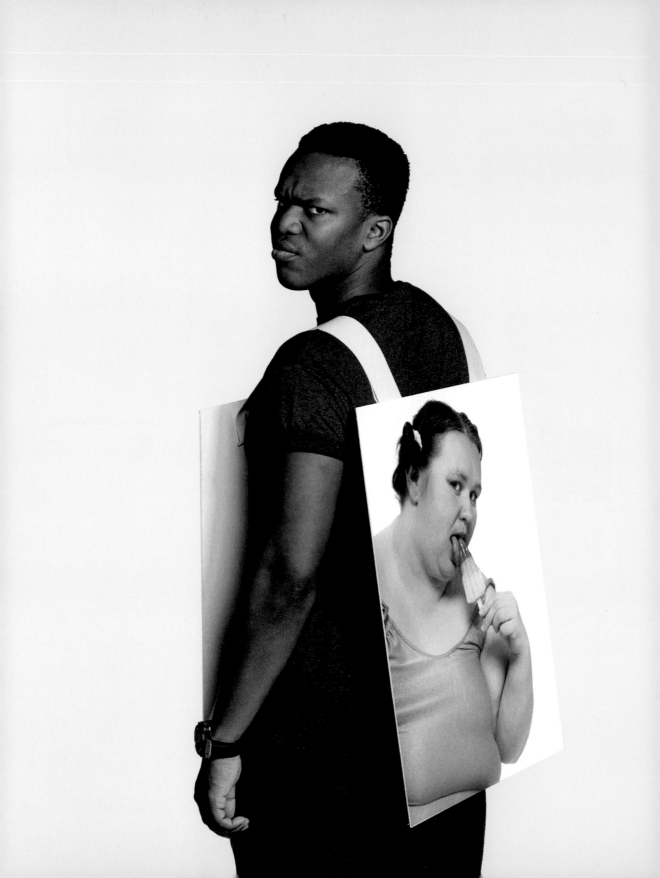

# STAYING SAFE ONLINE

Back in the day my mom used to keep me and Deji on lockdown. It was as if she thought the streets were full of psychotic, chainsaw-toting murderers and if we left the house without her they would chop us to pieces. Like, what the fuck would my mom have done if one of them had come up to us anyway?

Because we weren't allowed out, we spent all of our time on the computer instead. And, man, if ever there is a place full of psychos it's the internet. It used to blow my mind that we couldn't do shit in the normal world but online, where trolls, scammers, mentalists and pervs roamed, we could do whatever the fuck we pleased. Some of the stuff I saw used to give me nightmares : (

And even today, as a supposed grown-up (LOL), there is still a lot of shit you've got to watch out for online. If you're not careful you can get taken down hard – particularly tools like me who are always on the lookout for jokes! So, in order for you to sleep peacefully at night, I've highlighted the stuff you need to watch out for when you're online, and I've even taken revenge on some losers along the way ; )

# IF MY COMPUTER WAS HACKED WHAT WOULD YOU FIND?

It seems we can't go a month without some sort of celebrity hacking case being splashed all over the news. Sure, it's nice to see some X-rated nudie pics of your favourite actress, but deep down we all know it's a little fucked up.

It goes without saying that you gotta do everything you can to protect your passwords and computer, otherwise this shit could even happen to you. But, if there are any hackers eyeing me up, then let me save you the hassle. Here's exactly what you would find on my computer . . .

## PORN

Alright, calm your tits. Just like any hot-blooded male I've got shitloads of porn saved for a rainy day on my computer. These pics are actually tame compared to some of the stuff on there though, LOL!

## EMBARRASSING PHOTOS

Fuck, man. I really gotta delete this shit. These are no good for my street rep.

## MUSIC

Oh, yeah! Some badass boys right here. Other than to make videos, I probably use my computer most for music. And while I gotta lot of time for my hip hop, I also love bands like Breaking Benjamin. If you haven't heard of them, check them out. They're totally legit, and this is coming from a black dude!

## UNRELEASED YOUTUBE VIDEOS

Sometimes you can spend hours thinking up a video, and you start to believe you're a fucking genius! However, only after you've spent hours shooting do you realize you're actually a lunatic and it blows. I've got way too much of this shit clogging up my storage!

## PASSWORD FOLDER

Fuck, man. Now I've got to change every one of my goddamn passwords. Do you realize how many sites we need passwords for these days? I can't be expected to remember different passwords for every one of them!

Computer login: KSIRules
Password: PASSWORD

You tube login: KSIRules
Password: PSSWORD

Facebook login: KSIRules
Password: PSWORD

Twitter login: KSIRules
Password: PSWRD

FIFA login: KSIRules
Password: PWRD

Tinder login: MrBigCock
Password: PW

# LYRICS: Lamborghini

Got rocks on my wrist, that shit you can't resist
Cash flow greater than the haters hating on my gyst
Riding in your face, looking like I found a damn genie
Wilding in my Lamborghini
La-Lamborghini, La-Lamborghini
Bitch, I know you see me in my Lamborghini
La-Lamborghini, La-Lamborghini
Ride so quick, you would think I'm Houdini
Been in the game since Namco
Bring it back, I'm fully gassed yo
Vroom, vroom, in my brand new Lambo
Juiced up, and I don't give a damn yo
Going 120, and that's my slowest
On a one-way lane, like Lois
Who's that? Superman's bitch
Wanna see what happens when I touch the Superman switch?
Ride with more peers than Morgan
Drive past bloggers that are walking
I taunt them, Matt Lees, can you see me?
Wilding in my Lamborghini
When my Lambo on the track, fall back
When I'm riding at speed, get that neck crack
Blazing on the engine, everybody looking back
Like I'm shooting, gratata, got them going, 'fuck that'
Raise the fucking doors, I said make it look
Like a fucking eagle, like I'm starting wars
Dictating with my V12 Deagle, speeds ain't even legal
Scaring people, we ain't equal
Danny Glover ain't got shit on my motherfucking lethal weapon
Armageddon sounding when the man arrives
When we hype I come alive, like a 5 Alive
On the drive 21 years, smashing up the scene
And I keep on winning, like I'm Mr. Charlie Sheen

I'm always scribbling away, getting some
lyrics down for new joints, and this is
my rap song 'Lamborghini', which I
released with Jungle Money in March 2015.
I'm loving doing raps, man. It's something
I want to do more of in the future
because it's a laugh. Far-out excites me.

# HOW TO AVOID BEING LURED BY PERVS

I don't think I've ever been tricked by an online freak . . . But the fucked-up thing is, I might have been, and not even known about it. All those times I thought I was sexting some hot chick called 'Tamara', it could really have been an old dude called Ronald. When you think about it, that's scary shit! Man . . .

Now, I hope to God that none of you ever run into a perv online, but if you do, then take him back to skool with this advice (actually, don't do that, he'd like that, LOL):

✓ Just be 18. Yup. If you're over 18 then you can't be lured so it's all good. If you're not 18 then you'd better read on.

✓ It's a fact that no one has ever been stalked if they have a beard, so grow one out or stick some pubes on your face. Pervs hate facial hair!

✓ Think like a perv. I know, this is completely fucked up, but if you think like a perv you can't be lured by a perv, I think . . . Can you? I dunno, man, but if you think you might be a perv just punch yourself in the face and knock yourself out. That should stop you grooming.

✓ Don't talk to freaks! It's not hard, is it? If some weird dude starts hassling you for a dick pic then just don't entertain that nonsense and block the fucker. If the perv is, however, pretending to be a girl then that's hard, but if you ask them some really girly questions about make-up or periods, then you might be able to catch them.

✓ Be ugly. Pervs are unlikely to latch onto you if you look like dogshit, so never go online looking your best.

✓ Have a profile picture of you looking boss. Seriously, you want to look like you can do some damage. I find wearing a Rambo-style bandana usually does the trick. Pervs don't like messing with dudes who could properly fuck them up. Although some might be into that? Who knows, but if they are into that shit then just give them a beat-down anyway.

✓ If it's a female perv and they're hot, then just carry on being seduced. Is there a dude alive who would complain if a really hot older woman was hitting on them? However, if they look skanky then call the cops.

✓ Never go online. This way there's no way a perv can get you. Pretty tough to do but it's goddamn effective!

✓ Nah, time for shit to get real. If you do seriously think someone is acting strangely online, and might be a perv, you've got to tell someone, man, whether it's your parents, teachers or the cops. This is by far the best advice and will definitely put an end to the stalking.

# ONLINE PRANKS

Man, I love nothing more than pranking my mates online. And I've found that the best pranks are usually ones that go under the radar, where they don't even notice, and it can go on for months!

But before we begin, a word of warning: I once got into a whole world of shit for a prank that led to me being suspended from school. I had death threats and everything, so I'll be damned if I go over that ground again. Sure, the prank was comedy gold but, man, it got pretty dark. So, even though it's all jokes now, just make sure you're pranking a pal who can take it. You don't want any bad blood after it all goes down.

## CHANGE THEIR FACEBOOK RELATIONSHIP STATUS TO 'INTERESTED IN MEN'.

I did this to a mate over a year ago, and he still hasn't noticed, LOLs! This is definitely one of my favorites.

## 'LIKE' REALLY RANDOM PAGES.

Personally, I make sure my friends 'Like' all the gay pornstar pages so it comes up in their friends' timelines.

## SEND HORNY MESSAGES TO PEOPLE THEY DON'T KNOW.

This is a belter, and if anyone should reply it will go in your bro's 'other' folder, so he probably won't even see it.

## POKE RANDOM PEOPLE.
Does anyone even poke on Facebook anymore? Well, your pal does, and he's going on a poking spree, annoying the fuck out of everyone.

## FRIEND LOADS OF PEOPLE.
It's a friend-adding party and the whole damn world is invited. Your bro won't have a clue who all these random people are in his timeline, and when he does work it out he'll have to go through the embarrassment of deleting them all.

## CHANGE YOUR FRIEND'S BIRTHDAY TO TOMORROW.
When all those 'happy birthday' messages start rolling in you can just sit back and snicker as your mate tries to work out what the hell is going on.

## WRITE ON AN EX-GIRLFRIEND'S WALL FOR EVERYONE TO SEE.
Now, this will really piss your mate off, so you need to tread carefully, but it's still top laughs.

## BLOCK ALL THEIR FRIENDS.
Your pal will be wondering why Facebook is quiet and you will be laughing your tits off at his lonely ass.

## CHANGE THEIR PASSWORD.
Now, this isn't subtle but it is goddamn amusing.

## DEACTIVATE THEIR FACEBOOK.
Absolutely brutal and guaranteed to have them kicking off when they find out it was you. This really is Armageddon stuff, so you want to be damn sure he can take the jokes!

Now, if you want to avoid being a victim of these top LOLs then trust no one with your phone, computer or passwords. And when I say no one, I mean NO ONE!

# IDENTITY FRAUD

We've all lost our phone or bank cards at some point, usually after a night out. And sorting it out is an absolute bitch. But these days the stakes are even higher, as gangs are looking to steal your whole identity. Often all they need is your name, address and date of birth and they can pull off being you! This shit is crazy. But, y'know, this got me thinking: if someone was to steal my identity, what could they actually do?

## GO TO THE MOVIES

I've got an Odeon card that gives me unlimited entry to the movies every month, so if they want to check out a movie then they can go right ahead. Hopefully they'll see something really shit!

## GO TO THE GYM

They'd have to be mental to want to do this, but with my gym card they are welcome to smash up some weights and get a burn going on. As I haven't been in a while, my membership could probably do with some use anyway.

## USE MY NANDO'S LOYALTY CARD

Now, I go to Nando's a lot, and I've got a shitload of free chicken heading my way, so to lose out on this would make me mad. But these dudes could get themselves a helluva feast at my expense.

## USE MY AIR MILES

I've been lucky enough to travel all over the place in recent years, and right now I've got enough air miles to go pretty much anywhere for free. So, the world would be these fuckers' oyster. Las Vegas it is!

## WATCH MY BRAZZERS ACCOUNT

With my password they could fill their boots with all the porn they could handle. In fact, they'd be so busy doing this they'd be unlikely to do anything else.

## BLOW SOME CASH

Now, this would seriously piss me off. By all means go to the gym, or the movies, but if some fucker cleaned out my bank account and blew all my cash then, man, that would be brutal.

## POST SOME VIDEOS

I suppose if these guys have stolen my identity they could get onto my YouTube account and post some videos. This would actually be pretty hilarious. I'd actually be down with this!

## WATCH ARSENAL

With my Arsenal season ticket they could treat themselves to watching one of the world's best football teams. This would probably be for the best, as Arsenal always lose when I go watch them, so maybe these guys will have better luck.

It turns out that if you're me you can have a damn good time. Now, don't be getting any ideas!

# THWARTING A NIGERIAN SCAMMER

Now, as I'm half Nigerian I usually welcome emails from that part of the world. Who knows, it could be from a long-lost family member or an old friend wanting to chat some shit. However, more often than not, when I do get emails from Nigeria it's usually from complete fools. You see, for some reason my brothers from other mothers have cornered the market in email scams, and finding a Nigerian scam email in your inbox is like finding someone has done a steaming shit on your doormat.

Seriously, though, what dumb fucks still fall for this? Usually, these dudes' spelling and grammar is so bad it makes me look like Shakespeare. In fact, if you do lose your money to these pricks then I've got no sympathy for you!

Anyway, I'm goddamn tired of these sons of bitches trying to mug me off, so I decided to take them back to school purely for my amusement. Check it out!

---

**Abida.Majekodumni**                                    1:08 PM ☆ ⤺ ▼

My dear beloved one in Christ,

I am Abida and I am from Lagos, the capital of Nigeria. I write to you in the hope of brotherly love that you will be able to rectify a great wrong on me. I am currently awaiting trial on false charges and the government is trying to take my money. I must get $15 million out of the country immediately and I understand that you can help.

If you were to help me I would be happy to split the money 50/50 with you. Please provide following information so we can proceed quickly:

1. Name of your bank
2. Your address
3. Your bank account no
4. Private telephone and mobile no

Please hurry brother. If there is any delay then all of my money will be seized. Due to the top secret nature of this transaction please do not inform anyone.

My dreams rest squarely on your shoulders. May the almighty God continue to guide and protect you.

Regards, Your brother.

Abida! My brother from another mother!

Shit times for you but, man, all that money could come in really handy right now, 'cause I got Ebola and been bleeding out of my bum bum for a few days now (although it has made my balls massive ; ) ). Have you had Ebola yet?

Anyways, man, count me in! Only problem is I don't have a bank account right now, but as soon as my Ebola is cured then I will set one up.

As this is top secret we probably need code names for this operation. From now on I will call you Mr. Kid Toucher and you call me Mr. Big Dick. Deal?

Do you have any sexy bush African babe pics you can send my way as well? That would really put a smile on my face : )

Yours, Mr. Big Dick

**Abida.Majekodumni.Savile** 2:55 PM ☆

My precious Mr. Big Dick,

Your response is gratefully received. I am glad that I have met an honourable and trustworthy man such as yourself. I hope your Ebola clears up soon so that we can proceed.

In order to get the funds released my bank says that you must pay an admin fee of $2,500 to the Western Union Money Transfer today. Please do not delay as our money will soon be seized.

Your brother, Mr. Kid Toucher

**KSI** 3:39 PM ☆

Yo Mr. Kid Toucher!

Where's my bush African babe pic? C'mon, man, don't hold out on me.

Anyways, good news! My Ebola is clear! And I'm so excited about all this dough that I'm gonna get that I couldn't wait any longer, so I decided to visit a guy called Big Barry to borrow some major cash. He's charging crazy interest though, and says he will break my legs if I don't pay it back within a week, but fuck it, man, we gonna be making it rain real soon : )

Now I got all this dough I went wild. Check out the pictures! I got myself a new Lambo, a banging girlfriend called Shaniqua, and I even hit up KFC! You need to come out to Watford so we can party together. That would be sick!

Peace, Mr. Big Dick

Dear brother,

Thank you for your efforts in assisting me but I must have your bank account information immediately, as well as the Western Union transfer of $2,500. As soon as this is gratefully received then the bank will send you $15 million by electronic wire transfer within 24 hours. Which I trust you to hold my share until I am able to leave the country.

Let trust and honesty be our bond throughout this mutually beneficial transaction. May God bless you and your family.

Please hurry without delay.

Your brother, Abida

Bro,

What the fuck is wrong with you? Always remember that you are Mr. Kid Toucher in this operation! Do you want to get us banged up? Fuck, man, use your head!

Anyway, I'll get the bank stuff to you soon, but I've just been having a real good time with all this money Big Barry lent me. I took my girl to get some glamour shots done today (photos attached) and I even got the new Drake album! Do you like Drake? I like it when he raps about money and bitches, LOL. Guess what? I found out that it only costs $1m to get Drake to rap at a wedding, so I'm gonna ask my girl to marry me and then hire him. Of course you're invited : )

Gotta go as the Limo is waiting outside.  I'm throwing a sick party in London tonight in your honor.

Mr. Big Dick

PS: any chance you could send me an advance in cash real soon? Big Barry has started asking for his money back  : /

**Abida.Majekodumni.Savile**          6:52 PM ☆ ⤺ ▼

Dear Brother,

God bless you. It is a pleasure to know such a wise and honest man such as yourself. We have to make greater things happen in this life so that we will be a star and a legend in our generation.

The Lagos Bank has stressed that if they do not receive the Western Union transfer within 24 hours then they must hand my account over to the Government. Please hurry with utmost urgency brother and inform me as soon as you have made this transaction.

Let honesty, co-operation, and good faith be our motto throughout this transaction.

Yours, Mr. Kid Toucher

**KSI**          8:52 PM ☆ ⤺ ▼

Kid Toucher,

I went to send you the money but Big Barry found me and broke my legs. And now he's taken all my money and says if I don't pay him back within 24 hours he's gonna cut my dick off!!!!!!

You gotta pay and post me the cash quickly, man, otherwise I'm not gonna be able to hold all this money for us.

Drake is pretty pissed as well. I booked him for my wedding and now I can't pay : / Could you send him a tweet at @drake and tell him you will sort him out? I suppose it doesn't matter now anyway, as my girl, Shaniqua, has left me now I'm broke : (

Help!!!!!

**Abida.Majekodumni.Savile**          9:12 PM ☆ ⤺ ▼

Dear brother Big Dick,

What is the latest position on the Western Union transfer? It is vitally important that you wire the money immediately so that the bank can release the funds. As soon as this is done then you will be able to repay your Mr. Barry. Please hurry brother. There is not much time.

Yours, Mr. Kid Toucher

**KSI**          10:41 PM ☆ ⤺ ▼

FUCK!!!!!! They cut off my dick! My poor sweet dick! Why? Why??

I'm sorry, man, but I had to tell Barry that you had his money. I told him your name and address and he's got on a plane to Lagos to find you. Run man!!!! He said he's gonna take your dick and feed it to the lions.

Yours, Mr. No Dick : (

# KSI GETS DIAGNOSED

If you've ever had an embarrassing problem then you know that going to the docs for a check-up can be a painful experience. And I know this only too well!

A few years back I stupidly did the deed with some chick in Zante, without bagging up, and I was shitting myself when I got back home. I was convinced my cock was gonna fall off so I forced myself to see the doc, who only went and put a stick down the end of my cock! It hurt like fuck and it turned out I was clean, so it was all for nothing. If I had just looked online I probably could have diagnosed myself as suffering from nothing more than being a big pussy. And a moron for not being safe.

But it turns out I got some more embarrassing problems that are worrying me, and I'll be damned if I'm going see a real doc with them, so I decided to visit some well-known doctor websites to see if they could help a brother out with some of my 'issues'. This could take a while . . .

'DOCTOR, I CAN'T STOP EATING KFC. I EVEN WOKE UP THE OTHER DAY TO FIND I HAD FINISHED OFF A BARGAIN BUCKET IN MY SLEEP! DO YOU THINK I MIGHT BE ADDICTED?'

For this one I hit up the app 'Ask a Doctor'.

◇**Answered by Dr. Manish**

Ya, you might be addicted to taste. Few Days, you will get used to it and change it. Try for new variety. Anyway, this is not addiction, you are liking it. Not to worry.

...

Thanks

⏱Answered 8 minutes ago

Turns out that a KFC addiction is ok. Sweet! Thanks doc.

'DOCTOR, I CAN'T STOP WANKING OVER MY DEAD NANA. SHE'S BEEN DEAD FOR A WHILE BUT THOSE BONES REALLY TURN ME ON. AM I FUCKED IN THE HEAD OR WHAT?'

I asked the good people at 'First Opinion' about this issue, and they were pretty understanding.

Sorry to hear about your nana!

Thank you.
How can I stop?

I would try to distract myself and occupy my time with work, studies etc.

It's normal to remember a dear family member, who may have recently passed away.

I know it is difficult to get over personal losses but we all should make an attempt to move on. Many people practise breathing exercises, relaxation techniques and meditation. Would you like to try them?

Fuck me. Turns out there really is nothing wrong with thinking about my dead nana all the time. I've been telling you all in my videos that I wasn't sick in the head!!!

'DOCTOR, I CAN'T STOP HAVING UNCONTROLLABLE FIFA RAGE. IF I LOSE I JUST GO MENTAL, AND SMASH FURNITURE AND SHIT. I EVEN TOOK MY BOY HOSTAGE ONE TIME UNLESS HE AGREED TO PLAY ME AGAIN. IS THIS BAD?'

For this one 'Ask a Doctor' stepped up to the plate again.

◇**Answered by Dr. Manish**

Playing computer games or any games for that matter is not bad if done within a stipulated time frame without affecting the routine, personal and professional life.

If any of your personal or professional life is affected due to rage for playing computer games then you require counselling.

Thanks

🕐Answered 2 minutes ago        ✓**THANK**

Dayum! That's some food for thought right there. Fuck!

'DOCTOR, I CAN'T STOP GOING HYPER IN PUBLIC. WHENEVER I'M OUT THAT PHAT BEAT JUST POPS INTO MY HEAD AND I GOTTA LET MYSELF GO. I EVEN WENT HYPER IN CHURCH TODAY. WHAT IS WRONG WITH ME?'

Alright, I checked out Net Doctor, one of the most popular medical sites in the UK.

# Bipolar affective disorder (manic depression)

## What is bipolar affective disorder (manic depression)?

Bipolar affective disorder is also known as manic depression. It's a mood disorder.

The sufferer experiences marked mood swings, which are beyond what most people experience. These extremes of mood may include the lows of depression as well as the highs of a very elated mood (known as mania).

Fuck, man, this is deep!!!

'DOCTOR, I MASTURBATE AT LEAST FIVE TIMES A DAY. I'M LIKE A WANKING TORNADO. I WANK WHENEVER I CAN. I EVEN WANKED IN THE TRAIN STATION TOILET THE OTHER DAY : / ? IS THIS NORMAL?'

Ok, so rather than hit up some actual doctors I thought I would check out the wisdom of the internet at large for this one, and see what Yahoo had to say . . .

No, I average 5–8 times a week. You do it 21 to 35. Don't worry, your life can be extended over a decade by your activities.

Well, that's good advice. So far so good!

Dude, that's normal. I have done that many times before. You will calm down eventually.

I dunno, man, but thanks anyways!

When you're young, everything at first seems exciting and you want more and more of it until you get sick of it like last year's video game.

You'll get bored eventually. Just find other things to do and don't occupy yourself with it all day. Look forward to it like a reward when you go to bed.

Oh, it is a reward. A very, very regular reward : )

Yeah, dude, it's perfectly normal. You gotta do what you gotta do. I am also 15, and I can relate to you. EMAIL ME, I don't think I answered fully . . .LOL.

And now a perv is stalking me. For fuck's sake!!!!
I told you the internet was fucked.

So, besides having a perv try to share wanking stories, it turns out that, according to the internet, I'm bipolar, need counselling, and should try some meditation. Is this for real or LOLs? Fuck! Maybe I should just go to a real doctor in the future? This shit can't be right, can it?!

131

# DEJI'S INTERNET HISTORY

Internet rule number one: always, and I mean, always, delete your search history!

Oh, man, if my parents could see some of the shit I've looked up they'd probably get me committed. And I know you guys are just as bad. But it turns out that my bro, Deji, hasn't been as careful as he should, and has left his history for all to see. What an idiot! Obviously, I had to have a look, and show it to you all. Isn't that the law?

Date: Tuesday, 17 March, 2015

1.25 AM          http://www.brazzers.com/

Cool, bro, can't fault your taste. This is definitely my number one website so I can't really rip him for this.

1.27 AM          hentai porn – GOOGLE SEARCH

1.28 AM`         http://www.xvideos.com/tags/hentai

Oh, shit, here we go – right into cartoon porn land. This stuff just confuses the hell out of me. Why would you wank over a cartoon when there is so much great real porn out there?

1.47 AM          Why does it hurt when I cum? – GOOGLE SEARCH

Ha ha ha! Oh, man, that can't be good. But I gotta tip for you bro: your dick hurts because you're looking at shit porn and straining to bang one out. It's that simple. I gotta have some serious words with him when we are through here.

1.52 AM          Average size of a black man's penis? – GOOGLE SEARCH

Wahhahahhahaha, I'm dead! What's up, little bro, feeling inferior to your big bro in the trouser-snake department? Word is that the average length for a penis is five-and-three-quarter inches. Let's get the tape measure and check this shit out . . .
          Oh yeah!!!!! : )

1.54 AM          How to get a bigger dick? – GOOGLE SEARCH

Just wank, you dumb fuck! That pretty much works for me ; )

1.57 AM          When will North and South Korea become Team Korea? GOOGLE SEARCH

C'mon, man. It's time to put this shit to rest. That's like asking when Spurs and Arsenal are gonna join together to make one club. It just ain't gonna happen.

| 2.03 AM | https://m.youtube.com/watch?v=cD6w7b-SS38 | 🔍 |

What's this? Checkin out my videos are we, bro? Shame it's the one where I admit I'm a tool. That won't be any surprise to him!

| 2.05 AM | Am I adopted? – GOOGLE SEARCH | 🔍 |

LOL! Although if I was a brother of a tool I would probably wonder this as well. Who knows, maybe I'm adopted, 'cause I can remember Deji being born but I'll be damned if I can remember being born. Oh fuck . . . Mom? Mom?

| 2.08 AM | Cheats for Tekken – GOOGLE SEARCH | 🔍 |

No wonder this kid is always kicking my ass at Tekken. Cheating little prick! I swear, if he tries any of this shit the next time we play I'm gonna flat-out break a chair over his head.

| 2.13 AM | BB Guns – GOOGLE SEARCH | 🔍 |

Deji has been banging on about BB guns a lot lately. I swear he's planning to shoot me for a video. I gotta watch my back, or get him first. Don't mess, mo-fo!

| 2.22 AM | www.dominos.com | 🔍 |

Well, after porn, guns and cheating, what is a kid to do but stuff his face? This isn't such a bad idea. Is KFC still open? There's a Bargain Bucket with my name on it.

# STALKING MY TOP FANS

Unless you're a complete tool you've probably worked out by now that you gotta be damn careful what you show online. And I'm not even talking about posting nudey pics that pervs would sell their kidneys for. I'm just talking about regular, everyday stuff that could see your identity stolen or have your ex stalk the shit out of you.

Now, I know everyone is guilty of a little Facebook stalking from time to time, but that don't mean we all need locking away. Most stalking is relatively harmless stuff, and if you got your security filters locked down like a pro then there ain't a lot for anyone to see anyway. So, while we are on the subject, I thought I would 'stalk' some of my most supportive fans and see just who they are!

**Name:** Pedro Miguel Silva Viana
**Age:** 16
**Location:** Porto, Portugal

**Likes:** KSI, The Sidemen, FIFA 15, *The Big Bang Theory*, *The Lion King*, Nicholas Sparks

> What's up, Pedro! It always blows my mind that I got fans from all over the world. I hope Porto is treating you good, man. You got a sick-ass football team, as well as some beautiful ladies!

**Name:** Georgina Reynolds
**Age:** 17
**Location:** Kent

**Likes:** KSI, Call of Duty: Black Ops 2, *The Walking Dead*, *21 Jump Street*, *The Maze Runner*

> Yo! Georgina! How's it going, girl? Any girl who can put up with my shit deserves mad respect. And you're from my neck of the woods as well, so if you ever see me out and about, probably in Nando's, then make sure you give me a high five – or a kiss ; )

**Name:** Dan Harrison
**Age:** 16
**Location:** High Wycombe

**Likes:** KSI, Fifa 15, *The Big Bang Theory*, *The Book of Eli*, Drake, Logic

> Yes, Dan the Man. Props to this dude for always backing me up, no matter what crazy shit I come out with. Seriously, guys, if anyone is getting up in your grill then this mo-fo will sort them out for you.

**Name:** Freddy Moesle
**Age:** 15
**Location:** Duisburg, Germany

**Likes:** KSI, FIFA 13, Grand Theft Auto V, *House of Cards*, *Breaking Bad*, *Interstellar*, *The Wolf of Wall Street*, *The Godfather*, Lil Wayne, Drake, *Lord of the Rings*

> Looking good rocking those shades, my German bro! And I'm digging your film and music taste, man. Although I'm pretty sure you're still too young to watch *The Godfather*, you total badass!

**Name:** George Webber
**Age:** 14
**Location:** Bridgend
**Likes:** YouTube, KSI, Cardiff City, Tennis

> My man George is looking like he means serious business on that tennis court. Andy Murray, you gotta watch your back 'cause this guy is coming hard off the rails, and he ain't taking no prisoners. Make sure you save me courtside tickets for Wimbledon, dude!

You see! These dudes have their profiles locked down and everything but Facebook still lets me know a lot about them. Still, I got huge respect for my legit fans who have had my back since day one. Thanks, man, you guys make it all worthwhile and I'd be working in KFC if it wasn't for you.

Anyway, if you don't want to end up in a perv's wank-bank then listen up, 'cause you gotta make sure your Facebook profile is secure. All you gotta do is click on the 'More' icon, scroll on down to 'Privacy Shortcuts', and then make sure that the settings only allow your friends to see your posts and full profile. Seriously, man, if you haven't done this already then get to it, as at the very least it might prevent your mates hitting you with an epic prank . . .

# BEING AN ONLINE BADASS

You probably don't even know it but you are a total badass! Despite doing your best to keep your nose clean, you've probably broken more laws than hard-core criminals doing time. For real. You see, there are things all of us do online, every single day, that could land us in some serious shit, and I'm not talking about porn, for once! If you still don't know what I'm chatting on about, then just check out these things that are apparently against the law . . .

## SINGING 'HAPPY BIRTHDAY'

Prepare to have your mind blown: singing 'Happy Birthday' to someone online, or in the real world, can be considered illegal. WTF? Yup, the song is actually copyrighted and that's why you hardly ever see anyone sing it in movies. Apparently, Warner/Chappell Music own the copyright and make around $2 million per year in royalties from it. But don't worry. In the EU the copyright is due to expire on 31 December 2016, so then we can sing it as much as we goddamn like.

## RECORDING AND SHARING SKYPE OR FACETIME CONVERSATIONS

Has your mate done something ridiculous during an online chat? Or are you psyched about the hot babe you've been chatting up? That's all well and good, but if you record and share those conversations without their permission, you could be getting a knock on the door from the police. And us black guys need to be careful, 'cause if the police come knocking they will probably shoot us!

## PIRACY

Torrenting and sharing music, movies and TV shows is against all manner of laws and has seen people get fined, jailed and even banned from the internet. So, next time you're downloading an episode of *Breaking Bad*, ask yourself: is it worth being the pretty boy of Cell Block H?

## MEMES

That's right. In some cases, all those funny-ass memes you are making and posting are illegal, as the pictures are copyrighted. Sure, it's unlikely you're going to get locked up, but don't say I didn't warn you.

## WI-FI

Finding Wi-Fi when you're out and about can be a godsend, but did you know that it could be against the law? Yup, without the owner's permission, using unsecured Wi-Fi is apparently no different to going into their house and stealing their computer.

## SHARING PASSWORDS

We all know that guy who has passwords for everything, from Netflix to Brazzers. But guess what, bitches? If you don't pay for a subscription then using someone else's password is against the law.

## STREAMING FOOTBALL

It's 3 p.m. on a Saturday and you want to watch the game. But, in the UK, TV companies aren't allowed to show games being played at that time, which is a major ball-ache. However, TV companies in other countries are, and most of them are shown on streaming sites that we can view in the UK. However, a word of warning: watching it is against the law because, once again, it's copyrighted content. The Premier League would have a major-league hissy fit if they caught you out.

## AD-BLOCKERS

Man, nothing is more annoying than ads on a website. And these days it's so easy to get rid of them with an ad-blocker. But have you ever wondered how you're able to view most websites for free? It's because they have ads, you dumb fuck! So, if you cut out the ads,

you're getting a free ride on the website, which is just the same as watching an Arsenal game at the Emirates without paying for your ticket.

## YOUTUBE VIDEOS

You might wonder why you sometimes click on a YouTube video only to find that it has been taken down. Well, usually it's because the fucking tools have used a song in it without the owner's permission. So, if you're planning on making your own YouTube videos with music, then always make sure that you either have the owner's permission (which is almost impossible, unless you've got big bucks) or that the music is not copyrighted.

So just admit it, you're guilty as charged, you badass mo-fo! Time to perfect your gangsta walk, 'cause in jail you're gonna need it!

# KSI'S ONLINE SAFETY TEST

I've done all I can to warn you guys about some of the mental shit that goes down online, so let's see if you've been paying attention. Simply take the multiple-choice test below, and if you fail then you're not only a dumb fuck, but you shouldn't be allowed anywhere near the internet. And you thought the stakes were high with your SATs!

If an old man asks you to send him a picture of your dick, do you . . .
      a) Make your dick look as big as you can and send him the picture
      b) Ask him to send you a picture of his dick first
      c) Tell him to go fuck himself and call the cops

If your dick looks like it is about to fall off, do you . . .
      a) Wank to make it feel better
      b) Speak to an online doctor
      c) Go see your local doctor

When you finish wanking to porn, do you . . .
      a) Wipe your dick and get on with your day
      b) Finger your bum
      c) Delete your search history

If a weird Nigerian dude offers to make you a millionaire, and asks for your bank details, do you . . .
      a) Hand them over and wait for the money to roll in
      b) Spend the money 'cause it's coming real soon
      c) Ignore it 'cause it's a fucking scam

If some tool starts giving you serious hate do you . . .
      a) Bite back
      b) Curl up into a ball and cry
      c) Ignore the prick and don't give him the satisfaction

When you're coming up with passwords for your social-media accounts, do you . . .
- a) Just use 'password' 'cause it's easy to remember
- b) Use your pet's name
- c) Come up with something Fort Knox would be proud of, with capitals, numbers, underscores, hashtags etc.

If a weird website has the new series of *Game of Thrones* to download, but you need to type in your details first, do you . . .
- a) Hand that shit over and get the popcorn ready
- b) Look for *Breaking Bad* 'cause *Game of Thrones* is shit
- c) Ignore it because it's a fucking scam

If you're making a YouTube video, and need a really cool song to finish it off, do you . . .
- a) Raid Drake's greatest hits and upload the video pronto
- b) Raid Kanye's greatest hits and upload the video pronto
- c) Find music that isn't copyrighted, which might be a bit shit but won't get your ass in jail

If a really hot chick, who you don't know, tries to add you as a friend, do you . . .
- a) Accept the request and look at her pictures
- b) Ask 'Wanna fuck?'
- c) Ignore it 'cause it's a fucking scam

If someone you don't know sends you a link to open, do you . . .
- a) Open that shit and hope it's porn
- b) Open that shit and hope it's LOLs
- c) Ignore it 'cause it's a fucking scam

Right, it's results time – and it shouldn't take a genius to know that every single answer should be c). If you have answered anything that isn't c) then you are a total dumb fuck and it's only a matter of time before the internet swallows you whole. If you failed the test then read the goddamn chapter again. If you passed then join me in the next chapter, you clever fuck.

## OLAJIDE OLATUNJI
born on 19 June 1993

Timeline | Videos | Photos

**JIDE OLATUNJI** Great family holiday in Alicante! While **OLAJIDE OLATUNJI** and **DEJI OLATUNJI** are on the beach, me and **YINKA OLATUNJI** are taking advantage ; )

**OLAJIDE OLATUNJI** Da fuq????

**OLAJIDE OLATUNJI** YES! My YouTube video on FIFA has been accepted by Machinima!!! Gonna be making it rain real soon, bitches!!!

**SIMON WHITE** Since when have you been making YouTube videos, bro?

**OLAJIDE OLATUNJI** A few months now, didn't want to say anything until I got good : )

**OLAJIDE OLATUNJI**
Likes **LAMBORGHINI** 👍

**OLAJIDE OLATUNJI** Oh fuck! The YouTube video didn't work out so well. Peeps flat out want to murder me : (

**YINKA OLATUNJI** I told you to stop worrying about YouTube and concentrate on your exams!

**Prizes for Academic Distinction**

| | |
|---|---|
| Georgina Andrews | Geography, Music |
| Christopher Debonnaire | Business Studies, History, Science |
| Guy Fountaine | Biology, Drama, History |
| Oliver Goswell | Biology, Drama, Classical Civilisation |
| Emilia Gyles | History |
| Charles Holroyd | Art, Business Studies, Drama, Physics |
| James Holroyd | Biology, Drama, History |
| Oliver Johnson | Biology, Drama |
| Matthew Johnston | Design and Technology, Drama |
| Freddie Julius | Business Studies, Physics |
| Louis Little | Art, Biology, Drama |
| Matthew McGrory | Drama, History |
| Olajide Olatunji | Biology, Drama |
| Adrian Radu | Art, Biology, Business Studies |
| Alexander Rattan | Biology, Business Studies, Chemistry, Physics |
| Sidharth Sagar | Drama |
| Jonathan Shearer | History, Geography, Physics |
| Zachary Webb | Chemistry, English, Physics |
| Steven Wiggill | Biology, Business Studies, Physics |
| Archie Wood | Biology, Design and Technology |

**OLAJIDE OLATUNJI** As if me and my bro **SIMON MINTER** have been awarded Academic Distinctions! LOL!

**Prizes for Significant Achievement and Effort**

| | |
|---|---|
| Martin Aberson | Philippa Adams |
| Sophie Andrew | Georgina Andrews |
| Charlotte Ashby | Richard Atherton |
| Samuel Brabazon | John Bradfield |
| Eleanor Chiang | Millicent Clarke |
| Eloise Corswarem | Andre Dahlgren |
| Christopher Debonnaire | Anna Dixon |
| James Dolan | Lewis Elliott |
| Guy Fountaine | Robert Furlong |
| George Galloway | Piers Gibson-Birch |
| Alexander Goodridge | Liam Gordon |
| Emilia Gyles | Sarah Hocking |
| Daniel Hodkinson | Charles Holroyd |
| James Holroyd | Alexander Hunt |
| Oliver Johnson | Matthew Johnston |
| Rowan Jonas | Freddie Julius |
| Stephen Jullien | Ella Lamport |
| Sophie Langridge | Louis Little |
| Wai Hon Liu | Richard Llewellyn |
| Francesca Mears | Simon Minter |
| Natasha Mok | Christopher Moore |

**OLAJIDE OLATUNJI** is 19 today.

**JIDE OLATUNJI** Happy birthday son, or as me and your mom call it 'Happy We Had Sex Day!' ; )

**YINKA OLATUNJI** Likes this 👍

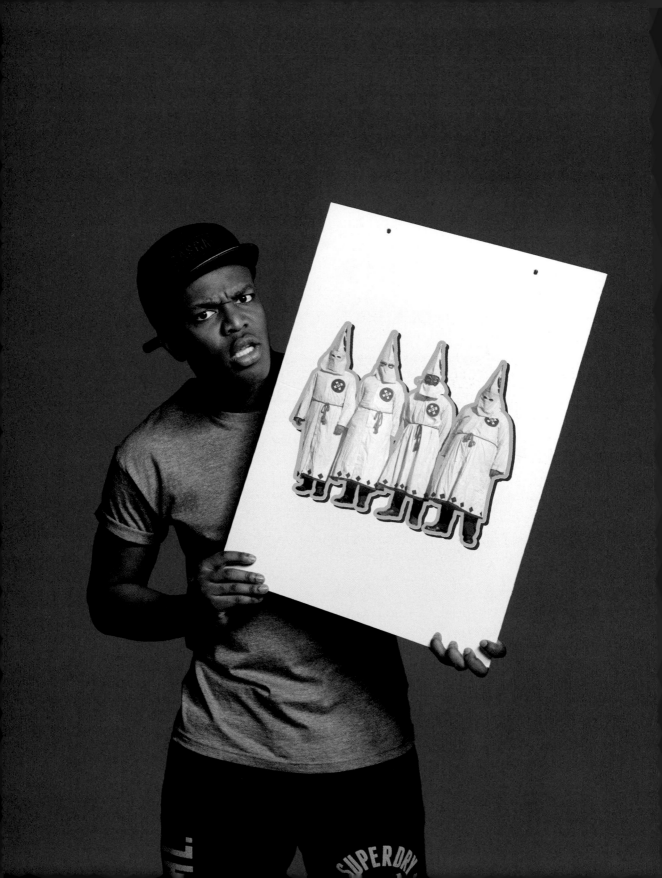

# EXPERIMENTING WITH THE INTERNET

We all like to experiment from time to time. After all, if we didn't experiment how would we know all the cool things you can do with your dick? But sometimes experimentation doesn't go down too well, like when I was 18 and got drunk for the first time (seriously).

Back then I went on vacation for a few days with my boys Calfreezy, Callux, Fearcrads and Zerkaa, and the night before we went to the theme park we stayed in a hotel. Down at the bar that night everyone started hitting the shots, so I thought I would join in, despite not really having drunk before.

Fuck, man, I'm telling you, after just a few sambucas I flat-out lost my mind. I started speaking complete shit, and the boys had to hold me up to stop me from falling on my face. I guess I must have blacked out, 'cause I can't remember much after that, but the boys tell me I passed out against a wall, as well as in the hotel corridor and even in a Lego pit! Da fuq?

The next day was just horrendous. It was the first hangover I ever had, and I had to go on all the rides. Oh, man, it was bad. I just wanted to throw myself off them and get my life over and done with.

Anyway, while that was shit, it's still sometimes fun to go off track, so why don't we do this online and experiment with the internet? But I gotta warn you, while some of the internet is good for LOLs, some of it will melt your brain, so prepare yourself for some sick shit!

# THINGS YOU'LL NEVER SEE A BLACK GUY DO ONLINE, UNTIL NOW . . .

It's goddamn hard being black online. If you don't believe me, just check out the comments to anything I post on social-media. I guarantee that someone will be calling me a 'nigger'! That shit is just fucked up.

With shit like that going down, sometimes I feel like I can't do certain things online. However, as I'm feeling ballsy right now, I'm gonna break down the racial barriers and post some stuff that no black man has ever done before . . .

**SHARE PICTURES OF HORSE RIDING**

**'LIKE' THE KU KLUX KLAN**

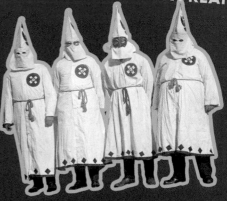

**SHARE A COUNTRY SONG**

**START STATUSES WITH 'I'M NOT TRYING TO BE RACIST BUT . . .'**

CHECK IN AT YO SUSHI

MAKE A YOUTUBE VIDEO
ABOUT BEING BULLIED

HAVE A PROFILE
PICTURE WITH A
POLICEMAN

INSTAGRAM A PICTURE
OF A SALAD

WRITE A PERFECT
GRAMMATICAL
SENTENCE

POST A PICTURE
IN THE DARK

# IF SOCIAL-MEDIA WAS REAL LIFE...

It's pretty clear that I, and many others, are full-on tools online. But would the same apply if we tried to act in real life as we do on social-media? Well, seeing as we are experimenting, let's check this shit out . . .

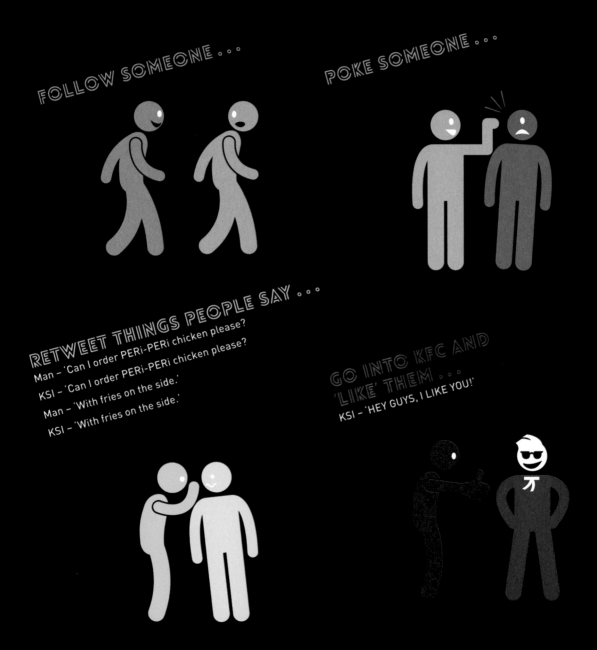

## ONLY SPEAK IN SENTENCES OF 140 CHARACTERS OR LESS . . .

MOM – 'How was your trip? Did you do much?'

KSI – 'America was cool. Our hotel was on Sunset Boulevard so we went out to a few nightclubs, and then in the day we hit up the beach in Santa Mon . . .'

MOM – 'JJ? JJ?'

## BE REALLY RACIST TO STRANGERS . . .

KSI – 'YO, NIGGER!'

STRANGER – 'What did you just say?'

## WALK AROUND WITH A DUCKFACE . . .

## BLOCK PEOPLE . . .

## UNLOAD ALL OF YOUR DRAMA TO STRANGERS . . .

KSI – 'Oh, man, I don't know what I'm gonna do with my life anymore. Someone called me a coon on Facebook, then someone called me a nigger on Twitter. And then . . . And then I stubbed my toe on the door, and it really, really hurts.'

WOW! This just goes to show that the online world is seriously fucked up. This shit could get you killed in real life.

147

# WEIRDEST THINGS YOU CAN BUY ON EBAY

Buying things online can be slick. You just see what you like, click 'Buy', and then in a day or two it turns up at your front door. Happy days!

However, I've had my fair share of being ripped off online, especially on eBay! Man, a few months back I wanted to buy a table, and saw what I thought was a decent one on there for $200 so I bought it. A few days later I went downstairs and saw a package lying on the doormat. I opened it up, and I'm being serious now, inside was a miniature table. The fuckers charged me $200 for a fucking model table! And I couldn't get my money back because apparently it was in the description. WTF?!!! It just goes to show you can buy any old shit on eBay. Seriously, man, just check this shit out.

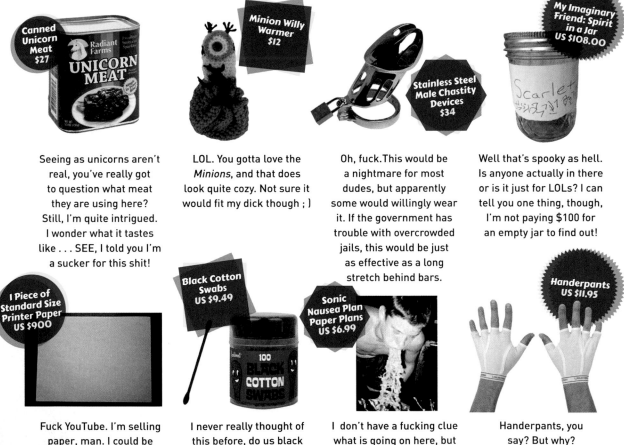

**Canned Unicorn Meat $27**

Seeing as unicorns aren't real, you've really got to question what meat they are using here? Still, I'm quite intrigued. I wonder what it tastes like . . . SEE, I told you I'm a sucker for this shit!

**Minion Willy Warmer $12**

LOL. You gotta love the *Minions*, and that does look quite cozy. Not sure it would fit my dick though ; )

**Stainless Steel Male Chastity Devices $34**

Oh, fuck. This would be a nightmare for most dudes, but apparently some would willingly wear it. If the government has trouble with overcrowded jails, this would be just as effective as a long stretch behind bars.

**My Imaginary Friend: Spirit in a Jar US $108.00**

Well that's spooky as hell. Is anyone actually in there or is it just for LOLs? I can tell you one thing, though, I'm not paying $100 for an empty jar to find out!

**I Piece of Standard Size Printer Paper US $900**

Fuck YouTube. I'm selling paper, man. I could be a goddamn billionare with prices like this.

**Black Cotton Swabs US $9.49**

I never really thought of this before, do us black dudes need black cotton swabs? Only one way to find out – 'BUY'.

**Sonic Nausea Plan Paper Plans US $6.99**

I don't have a fucking clue what is going on here, but the picture is enough to make me move along.

**Handerpants US $11.95**

Handerpants, you say? But why?

**Real Mommified Heart Necklace**
US $24.00

This for real? I know one thing, if I saw any girl wearing this I would run a mile. Maybe that's the idea . . .

**Rare, Large Kangaroo Scrotum Coin Bag**
US $18.00

HA HA. I actually quite like this.

**True Wicca 121-Year-Old Lost Spells**
US $9.00

Just $9? Even if it's fake that's got to be worth a look. And imagine if it actually worked! That would be major LOLs.

**Perverted Garden Gnome Flasher**
US $21.95

That's Mom's birthday present sorted this year. Thanks, eBay.

**Man's Thumbnail**
US $1.00

**Real Human Teeth**
US $40

Seriously, who the fuck would buy this? Although they could look quite cool on a chain, if you wanted to look like a cannibal. Actually, that would be pretty badass.

Why? Why? Why? This is grim man.

**Real Mommified Mice**
US $7.00

I suppose this would be good for LOLs if you wanted to scare your mom or girlfriend, but it's still damn creepy.

**My Soul**
US $5.05

Nah, I'm good man . . .

**Subtle Butt: Disposable Gas Neutralizers**
US $12.95

I know a few people in my house who could do with these!

**Fart in a Jar**
US $10.99

Man, I could be a factory just churning out farts day and night if people want to buy them at this price! I got a lot to go round so don't all rush now, LOL.

**Toilet Paper Roll, empty**
US $0.25

I may have to buy this just to freak the seller out. Surely no one has ever bought one before?

CHERNOBYL

NORTH KOREA

BAGHDAD

I gotta be honest, my vacation destinations are usually pretty standard. In the last few years I've hit up the likes of Zante and Ayia Napa, and had a damn good time, especially on the boat parties. I also had a really sick time in Vegas with my boys, where we stayed in a ridiculous room in the MGM Grand, which even had its own pool table, although I gotta admit I did end up losing a shitload of money when I was drunk like a total tool. Whoops!

So, with next summer around the corner and The Sidemen talking a good game about going somewhere different, I thought I would go online and see what was on offer. Turns out that if the traditional hot spots aren't your thing, you can go to some crazy places! Not too sure this is quite what the boys are looking for, though . . .

## CHERNOBYL

Imagine this: a city abandoned for almost 20 years. That's what happened to Chernobyl, in the Ukraine, after the city's nuclear power plant exploded in 1986, which meant everyone had to leave, and never return, unless they wanted to be toast. Literally, people just got up and ran for their lives, leaving things exactly as they were. Sounds like my living room after I unleash a massive fart . . .

Anyway, while people still can't live in Chernobyl, you can visit, courtesy of www.lupinetravel.co.uk who charge $700 per person for a tour. Sign me up for the abandoned fairground at night. That looks scary as hell.

## NORTH KOREA

If you thought an abandoned city was pretty cool then how about a whole country where virtually no one is allowed in or out? Well, that's the situation in North Korea, whose citizens have virtually no contact with the outside world. And they don't even have a KFC or Nando's! WTF!! I know – it's like the whole country is a jail.

However, while you can't just rock up to a place like North Korea, www.regent-holidays.co.uk organise limited tourist trips, where you are under military watch the whole time. You might not be able to take snaps for Instagram, but you can be damn sure none of your friends have been there before. I know Deji would definitely be down with this!

# VACATION TIME

## BAGHDAD

If neither Chernobyl nor North Korea sounds dangerous enough for you then why not try a proper war zone, like Baghdad? You'd have to be mental, but if it does tickle your fancy then the good people at www.abidintravels.com can sort you out. And you know it's crazy as hell out there, as the website keeps a body-count score. Dayum! And you thought some of the stuff I did was in bad taste . . .

## PALESTINE

Ok, so still nothing floating your boat? Then what about a mix of North Korea and Baghdad? If that has you nodding your head in excitement, you crazy fucker, then Palestine may just be the place for you.

With travel in and out of Palestine restricted by neighboring Israel, it can be tough to negotiate your way past the border, which is lined with soldiers holding machine guns. And you don't want to be unlucky enough to be stuck in Palestine with no way out should things kick off with Israel, as then you'll have to find shelter from bombs, which kinda sounds like some nightclubs I know from back home at closing time. Anyway, if you do have a death wish, and this still sounds like it's for you, then check out www.responsibletravel.com.

## BRADFORD

Now, if you're low on funds or just fancy a weekend away, then you might be thinking about somewhere in the UK. But I bet you've never even considered going to Bradford. Bradford? That's right. This city was named 'the most dangerous' in the UK in 2014 by YouGov, and judging by the picture above, it looks just as bad as Baghdad.

But hold up. If you go to www.visitbradford.com it kinda makes Bradford look nice, like something from *Downton Abbey*. So why not impress your mates by telling them you're braving Bradford, when in fact you're chilling in a country manor house. Win. Win.

So, who's coming to Vegas with me?

# THINGS YOU COULD BE DOING ONLINE RATHER THAN STUDY...

There you are, sitting at your computer, doing your homework, and porn is just one click away. I know, tempting. But what if I told you there was more to the internet than just writing essays and porn? For real! If you don't believe me then check out some of my favorite websites. They might not be as fun as porn, but they definitely beat studying.

## WWW.REDDIT.COM

This is probably my favorite website. It has pretty much everything you could want – funny Photoshops, gifs and memes, gaming tips, crazy stories, hot girls and even help with your homework. On the forums you'll meet some of the most interesting people of your life, as well as the most mentally imbalanced, but it's all good fun. If you can't find something here to entertain yourself then you're dead inside.

## HTTPS://ARCHIVE.ORG/WEB/

This is like jumping into an internet time machine, and it rocks! You can play any old computer game, from Nintendo and Sega to Playstation and more, watch old cartoons and movies, listen to audiobooks, and even try out the 'Wayback Machine', which shows you what your favorite websites used to look like back in the day. Your parents are always telling you to respect history, and this is the best place to do it.

## WWW.OMEGLE.COM

Fancy talking random shit about random subjects to complete strangers? Then all aboard the Omegle fun train, because this can handle all the randomness you're looking for. Plus, you can meet some pretty cool people and enjoy some banter, as long as you're not being a complete dick. Although that can be fun to do from time to time ; )

## HTTP://WWW. COLLEGEHUMOR.COM/

Do you just want to laugh your tits off at some really inappropriate stuff? Who doesn't?! And this place is as inappropriate as they come. It's guaranteed to have you pissing your pants. Literally.

## WWW.FOOTYTUBE.COM

If you need a soccer fix then check this joint out. It's got the latest news, match highlights and interviews from all the clubs, as well as a forum where you can give out shit to rival fans.

## WWW.EFUKT.COM

Listen, I know I said no porn, but this doesn't really count. This is more like a collection of epic fails from porn movies, with some hilarious editing. If you get a boner watching this then there's something wrong with you, man. It's just for LOLs.

## WWW.RASTERBATOR.NET

Despite the name of the website this has absolutely nothing to do with porn. For real. It's a site where you can design your own poster using pictures from the internet, and either print it yourself or order a professional vinyl version.

## WWW.LONGREADS.COM

Sometimes you just want to read a well written, mental true story, and this site has plenty of those. Collating all of the best true stories ever written, from a variety of worldwide newspapers and magazines, you can read about everything from serial killers and bank jobs to tech start-ups, and a whole lot more.

## WWW.YOUTUBE.COM/USER/ KSIOLAJIDEBT

Did you really think I was going to make a list of the coolest places to visit on the internet and not include my own YouTube channel? You must be crazy. But I guess you visit it already, and if you don't then join me for regular videos featuring FIFA, tantrums, random games and really inappropriate comedy.

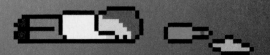

# KSI TESTS NEW TECHNOLOGY

There is some crazy new technology getting ready to land real soon, which is totally going to change the game. And I'm not just talking about the latest iPhone. I'm talking about stuff that could mean you can travel to wherever you want in seconds, date your perfect girl and even live forever. For real! So, liking the sound of this, I decided to check it out for myself. Prepare to have your minds blown.

## 3D PRINTER

These bad-boys actually exist right now, and as the price drops soon everyone will have one, especially with Amazon recently opening a 3D printing store. While they can already make things like jewellery, drones, game pads, guns and shoes, it's the next generation of 3D printers that are blowing my mind. Apparently, these miracle workers are gonna be able to make food! Are you thinking what I'm thinking? KFC on tap!!! You'd never have to leave the house again.

## HOLOGRAMS

Man, who can forget seeing that Tupac hologram rock up at Coachella a few years back. That shit was cray! And soon it will be cheap enough for us all to do it. While we currently use filters and photo-editing apps to make our lives look sick, imagine when we can actually make a perfect hologram version of ourselves and get them doing all the shit we want to do but are too scared to. For example, want to swim with sharks without shitting yourself? Your hologram can dive right in there while you take the picture.

## THE PERFECT RELATIONSHIP

Have you seen that really trippy movie *Her*, where Joaquin Phoenix has a relationship with his computer? And I'm not just talking about wanking to porn, but an actual real relationship. It's messed up but the computer is voiced by Scarlet Johansson, and she sounds smoking. So, with this possibility apparently not too far away you could soon have your perfect relationship, hassle free. Count me in for the Beyoncé voice and the Melissa McCarthy personality. Sexy and funny! BOOM!

## ETERNAL LIFE

Soon you won't have to find the Holy Grail to be able to live forever. You just need to have used a social-media account in your lifetime. Word is that scientists are developing a system that will be able to collate all of your social-media posts so that they can determine your personality. This will then allow a computer to predict what you would say on any given subject. And with it also being able to replicate your voice, you could be giving out shit long after you've bitten the dust. They better hurry the fuck on with this; I could make YouTube videos forever!

## TRANSPORTER

We've all seen those sci-fi movies where at a click of a button someone can travel to the other side of the world in less than a second. While this is still someway from becoming reality, scientists have recently edged a little closer. An experiment, conducted at Delft University in the Netherlands, saw a few particles of matter transported across a distance of three meters. It may not be much but it goes to show it's possible. Let's hope they crack the code quickly as I've got my sunglasses packed and I'm ready to hit Vegas for a few hours.

## DRIVERLESS CARS

Listen, I don't care if this car can drive itself, you won't catch me sitting in something that looks so completely shit. Thankfully, this is just a prototype so hopefully Google will take some inspiration from Ferrari or something, before they start selling them. But, anyway, driverless cars are coming real soon. In fact, from January 2015 manufacturers have legally been allowed to test them on British roads. This could be a lifesaver. Imagine if after a night out you didn't have to wait for a taxi anymore – or if you're too young to drive!

# KSI VISITS THE DARK WEB

Oh, shit! Here we go. KSI is about to hit up the Dark Web, AKA The Secret Internet!

If you've been living in a cave, and don't know what I'm talking about, this is a whole side of the internet that you can't find on any standard search engine. Why would anyone want to put something on the internet that people can't find? Because it's shady as fuck. One of the Dark Web's most famous sites, which was raided by the Feds in 2013, was 'Silk Road', an online marketplace, much like Amazon, but where you could buy all sorts of mental shit. And while Silk Road is no more, there are still a lot of wild things on the Dark Web that will blow your mind.

Now, visiting the Dark Web is legal, but most of the things you will find on there are not. So, let me make this real clear before we begin. If you do decide to join me on this adventure, BE VERY CAREFUL AND DO NOT CLICK ON ANYTHING THAT MIGHT BE ILLEGAL. I'm serious, man. There is stuff on here that could scar you for life and see you locked up. This is not something to be playing around with.

Scared? Me too. Here we go.

# THE HIDDEN WIKI

Apparently, The Hidden Wiki is the best place to start exploring, so let's have a gander.

## RENT A HACKER

Straight off the bat we can hire a hacker to hack into just about anywhere. Cool :)

## ASSASSINS

Oh, fuck, here we go. Turns out you really can hire assassins on the Dark Web! Don't you mess with me now. I know where you live, LOL.

## GUNS, FAKE IDs AND PASSPORTS

For the bona fide gangsta, the Alpaca Marketplace can handle all of your bad-boy needs and send you directly to jail! I'm just going to stick at playing a bad-boy on YouTube. This shit is too intense.

## COUNTERFEIT MONEY

If counterfeit money is your thing, then guess what? The Dark Web is the place for you. You could be making it rain forever at these prices.

So, just in case you are dumb fucks and you didn't get the message, the Dark Web is one fucked-up place. DO NOT go on there! You'll either end up in jail or in a mental institution. I'm going to call my mom . . .

# IS THE INTERNET RACIST?

Now, I've already come clean about being a tool. But man, there are some other MAJOR tools online as well. If you've ever read the comments to anything I've posted, you'll know for sure that there are some racist mo-fos lurking around in the cyber-world. But while that ain't no surprise, it did get me thinking: are some websites more racist than others? Well, seeing as we are experimenting, why don't we measure them up . . .

## GOOGLE
Let's start this off with a simple search term, like: 'Can black . . .'

'Can black people float?' WTF!! And that's one of the top search terms. Fuck, man. If Google isn't racist it certainly shows that there are a huge amount of dumb fucks in this world. Lord have mercy!

## INSTAGRAM
Ah, man, Instagram is just pure chill. This is like a hippy haven in the middle of a nuclear war zone. But are there any tools lurking here? Only one way to find out . . .

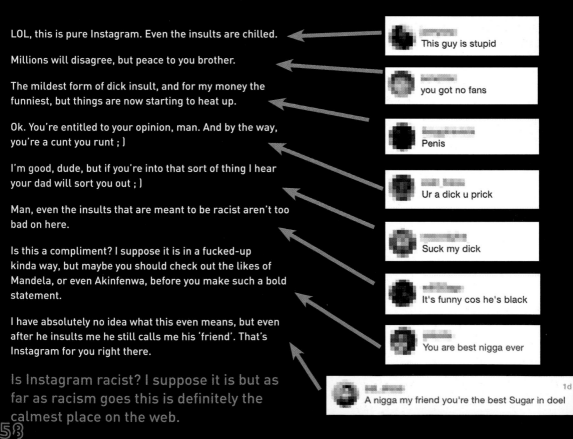

LOL, this is pure Instagram. Even the insults are chilled.

Millions will disagree, but peace to you brother.

The mildest form of dick insult, and for my money the funniest, but things are now starting to heat up.

Ok. You're entitled to your opinion, man. And by the way, you're a cunt you runt ; )

I'm good, dude, but if you're into that sort of thing I hear your dad will sort you out ; )

Man, even the insults that are meant to be racist aren't too bad on here.

Is this a compliment? I suppose it is in a fucked-up kinda way, but maybe you should check out the likes of Mandela, or even Akinfenwa, before you make such a bold statement.

I have absolutely no idea what this even means, but even after he insults me he still calls me his 'friend'. That's Instagram for you right there.

Is Instagram racist? I suppose it is but as far as racism goes this is definitely the calmest place on the web.

58

# YOUTUBE

Alright, this is my main domain, and I got a lot of love for this site. But is it racist? Well let's just dive right on in and search again for, 'Can black . . .'

This shit might not be racist but it does go to show there are some total tools out there. Although it does raise a valid point, can black people be emo?

Anyways, we're not done just yet with YouTube. Let's take a look at the comments page to some of my videos to really check this shit out . . .

| can black | × Q |
| --- | --- |
| can black **people be racist** | ↖ |
| can black **people get lice** | ↖ |
| can black **people be emo** | ↖ |
| can black **people swim** | ↖ |

Cool story, bro! ←——————————————

> IM BLACK AND IM PROUD

None taken. At least you're honest. ←————

> I am racist, no offense.

Pretty sure that's a country in Africa, but I'm getting the racist vibe here anyway. ←————

> fuck u niger

Why would you even say that? White people love KFC as much as black people, you moron, so we'd all be fucked! ←————

> I hope KFC does close down because there wouldn't be as many fat niggers running around!!!!!

This ain't too subtle. We're getting in deep now . . . ←————

> Fucking monkey niggers ! Hakuna matataaaa !

Things are definitely heating up, but hold on, I'm sure there is another level of dick to go yet . . . ←————

> Nigga nigga nigga. Ksi is a ugly nigga nigga nigga nigga nigga ksi is a nigga

We have a winner! Congrats, dude, out of all of YouTube you win the biggest tool prize. ←————

> Your a nigga Ksi just eat your little African 1inch wonder dick you FUCKING EBOLA CUNT

But thankfully, while there are some prime dick mongerers on YouTube, there are also some pretty cool dudes, like this guy . . . ←————

> I love all of my black people from around the world..... black is beautiful

So, YouTube has its fair share of tools, and definitely needs to Man the Fuck Up to weed these tools out, but is it the worst site? Not by a long shot . . .

159

# FACEBOOK

Alright, then, we're going in on Facebook, where most people seem to post comments to my stuff just for LOLs. However, that don't mean there aren't some goddamn fools on there. Let's check out some comments to my posts . . .

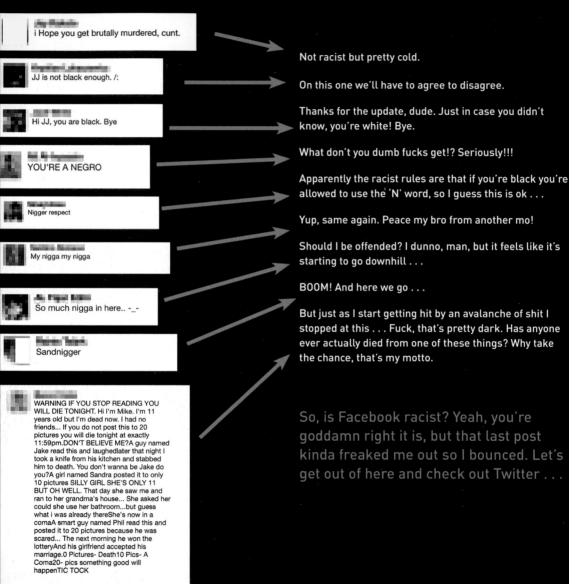

i Hope you get brutally murdered, cunt.

**Not racist but pretty cold.**

JJ is not black enough. /:

**On this one we'll have to agree to disagree.**

Hi JJ, you are black. Bye

**Thanks for the update, dude. Just in case you didn't know, you're white! Bye.**

YOU'RE A NEGRO

**What don't you dumb fucks get!? Seriously!!!**

Nigger respect

**Apparently the racist rules are that if you're black you're allowed to use the 'N' word, so I guess this is ok . . .**

My nigga my nigga

**Yup, same again. Peace my bro from another mo!**

So much nigga in here.. -_-

**Should I be offended? I dunno, man, but it feels like it's starting to go downhill . . .**

Sandnigger

**BOOM! And here we go . . .**

**But just as I start getting hit by an avalanche of shit I stopped at this . . . Fuck, that's pretty dark. Has anyone ever actually died from one of these things? Why take the chance, that's my motto.**

WARNING IF YOU STOP READING YOU WILL DIE TONIGHT. Hi I'm Mike. I'm 11 years old but I'm dead now. I had no friends... If you do not post this to 20 pictures you will die tonight at exactly 11:59pm.DON'T BELIEVE ME?A guy named Jake read this and laughedlater that night I took a knife from his kitchen and stabbed him to death. You don't wanna be Jake do you?A girl named Sandra posted it to only 10 pictures SILLY GIRL SHE'S ONLY 11 BUT OH WELL. That day she saw me and ran to her grandma's house... She asked her could she use her bathroom...but guess what i was already thereShe's now in a comaA smart guy named Phil read this and posted it to 20 pictures because he was scared... The next morning he won the lotteryAnd his girlfriend accepted his marriage.0 Pictures- Death10 Pics- A Coma20- pics something good will happenTIC TOCK

**So, is Facebook racist? Yeah, you're goddamn right it is, but that last post kinda freaked me out so I bounced. Let's get out of here and check out Twitter . . .**

# TWITTER

Oh, yes, here we go. This is where shit gets serious. Among all the cool peeps Twitter is a full-on asylum at times. I've seen stuff on there that makes my blood turn cold. Just check this shit out . . .

Not racist but really fucked up. Why would you let your child on Twitter if they were 8?

> @KSIOlajidebt My mom said I can't go cus I'm 8 years old and lost my Virginity at 4 :(
> 06/02/2015

Straight in with the insults but again, man, if you don't like my shit I can handle your opinion. I'm a big boy.

> @KSIOlajidebt cunt
> 18h

> @KSIOlajidebt get cancer
> 18h

Is this racist? I dunno, man, maybe he just digs white T-shirts? I'm prepared to give the benefit of the doubt here, 'cause I'm in a good mood.

> @KSIOlajidebt wish they were white t shirts instead of black
> 06/02/2015

It's 'you're' you dumbass!

Now, that's pretty racist, but they did say 'please', so at least they're a polite racist.

> @KSIOlajidebt your so black I can't even see you ffs
> 2d

Here we go . . .

> @KSIOlajidebt shut up, back to the jungle please
> 3d

And it's in BEAST mode now . . .

> @KSIOlajidebt nigger

Woah! Let's just take a moment and analyze this shit right here. This guy is not only a flat-out racist, but he's also calling me dumb and telling me to go back to school, while at the same time spelling 'dumb' and 'school' wrong. Seriously, man, you can't make this shit up!

> @KSIOlajidebt coon

> @KSIOlajidebt @respickt hey mr niggrr gow about u go nack too schoooll u dumvb nigger habab
> 18h

Yup. That's as stone-cold racist as they come. Give this dick a prize.

> @KSIOlajidebt I HOPE YOU GET EBOLA YOU FAT LIP NIGGA CUNT

But then I see this, and realize that some racial stereotypes can work in my favor ; )

> @ksiolajidebt I want black dick

No surprises but Twitter is the big prizewinner when it comes to racist shit. Just check out anything I post and it's littered with racial slurs. Twitter needs to up its game big time! I gotta be honest, man, I laugh a lot of this shit off, but it's starting to get out of hand.

I guess that all goes to show that it can be hard being a black dude online these days. I hold my hands up, man, I've said and done a lot of dumb things in my life but I'm trying to get my game together, and some of you out there need to do the same. Just remember, don't hate, congratulate : )

# MAKE MY TOOL GO VIRAL

It seriously amazes me, some of the stupid shit that goes viral these days. But who am I to complain? I love stupid shit more than most!

Anyway, this got me thinking: what's the most dumb-as-shit thing we can get to go viral? Well, as this book is about tools, I thought it would be major LOLs if we got an actual tool going around social-media. So, listen up! All you gotta do is screenshot the picture below, and post it on Twitter, along with the tweet:

## LOL. I can't believe how small my tool is #KSItool

Together we can merk off the entire internet and prove that literally any shit can go viral.

## BOOK

**@gxnsf0rhands How long did it take you to come up with the title?**

Ummmm . . . probably about ten seconds. I just thought, I'm a tool, so why not call it that if the book is about me. Fuck it!

**@sangayyyy How is it, being a tool?**

You know what, it's good. Every now and then I spurt out white juice, which is a bit weird, but yeah, it's cool.

**@happilygemma Is it appropriate to read in my English lesson?**

Yeah, fuck it, why not? Whatever gets you guys reading.

**@courleycutler Will you put this in your book?**

Yes. Well played. You've fucked up the system.

## LIFE

**@TrixAsylum123 What is the funniest thing that happened to you in your childhood?**

My grandma once accidentally slammed my hand between the doorframe and the door. It hurt like a fucker, and now my little finger won't straighten, but other than that it was pretty jokes. I suppose you had to be there, 'cause reading this back it actually doesn't sound funny at all, but seriously, man, we laughed like fuck at the time.

**@Momopixo Favorite ever experience with a fan?**

Uhhhhhhh . . . I guess while I was recently driving my Lambo in London I had literally 15 kids step in front of my car and beg me for a picture. That was sick! They were all cool as well, so it was a good feeling to be recognized and see everyone happy to see me.

**@eroydenlocke What was the best and worst decision you've made?**

The best was probably to drop out of school and get on YouTube. The worst decision was definitely not being more of a dick in school. If I knew what I know now, I would've just been more of a complete twat. I would get to the point where I wouldn't get suspended but would just cause chaos. Back in school I was such an

introvert. Seriously, I just feel like I should have been more of a dick. Ahhhh, man, I needed to get that off my chest. Anyway . . .

**@TheBlueAero What has been your greatest moment so far?**

Having a threesome. Nothing else comes close.

**@cubesmps2fan Favorite singer?**

Uhhhh, that's tough. I quite like that song 'I Keep Forgettin' by Michael McDonald so let's give the crown to that dude.

**@mullins2320 The worst thing you've done when drunk?**

Punch a baby . . . Nah I'm kidding. I'M KIDDING!!!! To be honest, I'm pretty chilled when I'm drunk. I'm just happy, man. I do my dumbest shit when I'm sober.

**@chedda96 You have made songs, filmed webshows/TV, written a book, and made YouTube content. What is next for you and your career?**

Porn!

# KSIBOOK

## OLAJIDE OLATUNJI
born on 19 June 1993

Timeline | Videos | Photos

**OLAJIDE OLATUNJI** Likes **ZERKAAHD** 👍

**OLAJIDE OLATUNJI** Likes **SA SPORTS GAMING CHANNEL** 👍

**OLAJIDE OLATUNJI** Worst day ever but don't really want to talk about it . . .

> **SIMON MINTER** What happened, bro?

> **OLAJIDE OLATUNJI** Failed my high school exit exams. Either have to try again or suck off dudes to make money : (

> **DEJI OLATUNJI** LOL!

 **OLAJIDE OLATUNJI** BOOM! I made $20 this month through my FIFA commentating video : )

**JOSH ZERKER**
After Machinima I didn't think you were gonna go on YouTube anymore?

**OLAJIDE OLATUNJI**
I thought I would give it one more go : )

 **OLAJIDE OLATUNJI** I'm feeling so blessed with my YouTube success that I decided to help some orphans. Got to remain humble!

 **OLAJIDE OLATUNJI** Liked **CHARLOTTE MILES** picture 👍

**CHARLOTTE MILES** Vacation time : ) #nofilter

**JIDE OLATUNJI** Damn, Charlotte, it's a good thing I'm not 30 years younger!

**OLAJIDE OLATUNJI** Dad!

**JIDE OLATUNJI** I'm only human, LOL. Anyway, didn't you say you like her as well?

**OLAJIDE OLATUNJI** FFS!!!!!!!!!!!!!

# WHEN THE INTERNET GOES WRONG

The internet gets a lot right. Porn for one. However, it also gets a lot wrong, and when it gets it wrong, it can get it catastrophically wrong. I'm talking about the type of shit that can see people shamed, and even jailed, as well as bring multinational corporations and governments to their knees.

I've had my fair share of online disasters myself, particularly after the first video that I had shown on Machinima had peeps lose their minds. For the video I tested out a different online persona, which believe it or not was even more of a tool than I am in real life. I went all-out gangsta, being proper arrogant and everything. I couldn't believe it when everyone took what was meant to be LOLs seriously. After that I had death threats and everything. For a while I even stopped posting on YouTube, I got so stressed out from the hate.

So, in order to avoid any drama, I'm gonna show you all just how badly the internet can completely fuck your life up if you're not careful. It's a minefield out there!

# AUTOCORRECT FAILS

You know how it is: you just want to send a quick text message to your family or friends, and get on with your life. But autocorrect just likes to fuck shit up, and leave you looking like a total tool. I've sent and received some horrific ones in my time, so let this be a lesson to you all: read your messages twice before you press send!

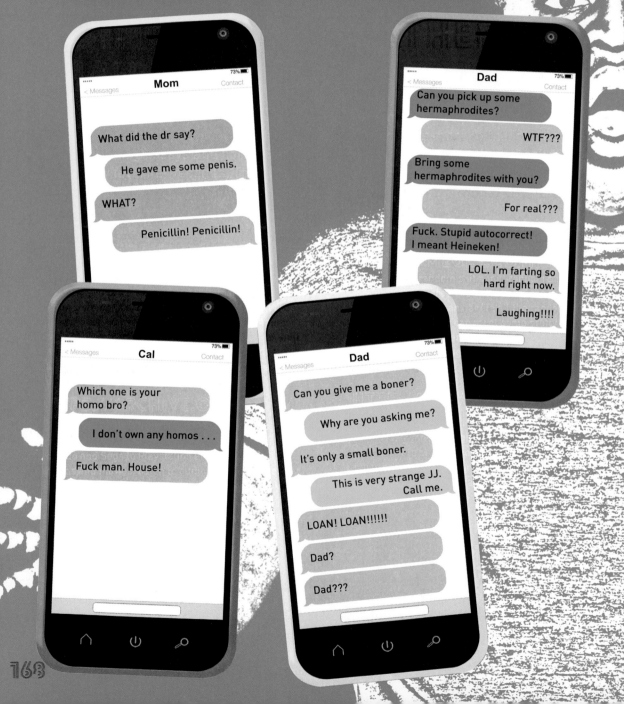

**Mom**

What did the dr say?

He gave me some penis.

WHAT?

Penicillin! Penicillin!

**Dad**

Can you pick up some hermaphrodites?

WTF???

Bring some hermaphrodites with you?

For real???

Fuck. Stupid autocorrect! I meant Heineken!

LOL. I'm farting so hard right now.

Laughing!!!!

**Cal**

Which one is your homo bro?

I don't own any homos . . .

Fuck man. House!

**Dad**

Can you give me a boner?

Why are you asking me?

It's only a small boner.

This is very strange JJ. Call me.

LOAN! LOAN!!!!!!

Dad?

Dad???

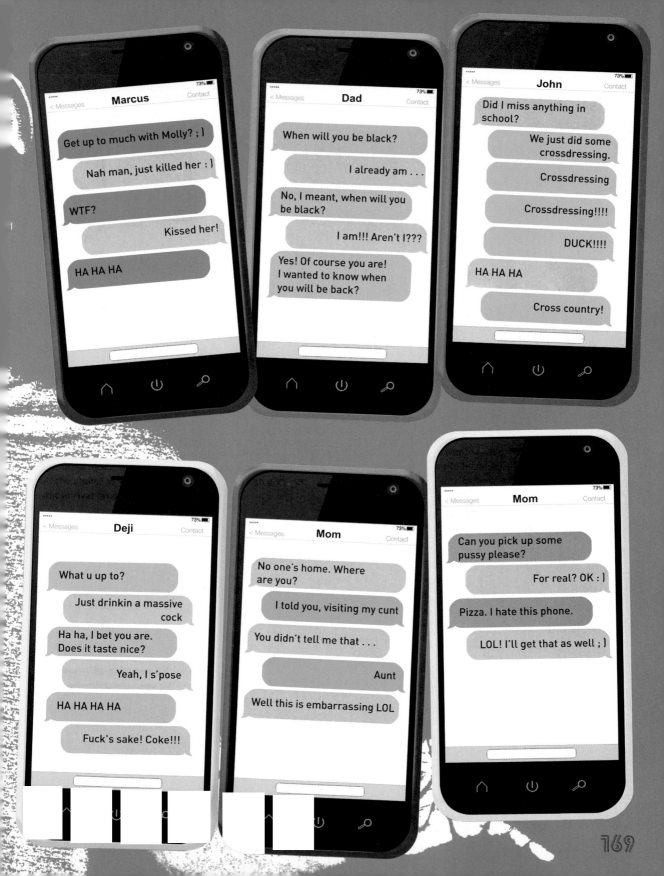

# WHEN COMPANIES GET SOCIAL-MEDIA WRONG...

Thankfully, my fans are so used to me making a tool out of myself that I can pretty much get away with posting anything online and no one will bat an eyelid. It's a nice position to be in, as if I ever make a major fuck-up I can just post 'LOLs' afterwards and all is good.

However, it's a whole different ball game for companies and certain individuals. For them, being online means they've constantly got to be on their best behaviour, as any fuck-up can lead to total disgrace. But even though they know the pressure is on, some of them have still managed to look like complete cocks. So, sit back and laugh hard at these epic fails from people who really should know better.

## SUSAN BOYLE

When Susan Boyle's PR team decided to use the hashtag #susanalbumparty to promote her latest album, my brother, Deji, went along to the launch. He tells me that it wasn't quite what he expected, though, as there was a white woman singing and no sign of any anal bum party. Better luck next time, bro ; )

#SUSANALBUMPARTY

Donald J. Trump
@realDonaldTrump

"@_____: My parents who passed away always said you were big inspiration.Can you pls RT for their memory? pic.twitter.com/o2BOGnYhaN"

## DONALD TRUMP

I always thought that to be a billionaire you had to be really clever, like that dude from *The Chase*. So it figures that a gazillionaire like Donald Trump must be a genius. Not so much. After being asked to retweet a picture of a follower's 'parents', big-hearted Donald did just that, except the picture was actually of serial-killers Fred and Rose West . . .

## LONDON LUTON AIRPORT

I hate flying. The food is shit and it's scary as hell. So when an airport posts a picture of a plane crash, to prove what a great place it is, that's already a little fucked up. But when the picture is also from a crash where a child died, man . . .

London Luton Airport
Because we are such a super airport.... this is what we prever from when it snows... Weeeee :)

LONDON LUTON

 Facebook.com/LDNLutonAirport
@LDNLutonAirport
http://pinterest.com/LdnLutonAirport

BlackBerry
@BlackBerry

Keep up with the conversation on @twitter instagram.com/p/xzh-3HGrKm/ pic.twitter.com/a5gWaO19CB

2:08pm - 13 Jan 2015 · Twitter for iPhone

## BLACKBERRY

Nothing wrong here. Just your standard BlackBerry promotional post. But what's that in the corner? 'Twitter for iPhone'. HA HA HA HA! Just stop! It's done.

## CELEBRITY BOUTIQUE

When your company is based in a tiny little town like Aurora, and suddenly the town name is trending, then you gotta dive right in there and let the whole world know about your 'Kim K inspired #Aurora dress.' And why not add a little winking smiley face in there for good measure. But when Aurora is trending for the first time EVER, then it might be a good idea to check the fuck why before you use that hashtag, as it might be because some lunatic has just murdered 12 people in a local cinema. Oh . . .

**Celeb Boutique**
@celebboutique

#Aurora is trending, clearly about our Kim K inspired #Aurora dress ;) Shop: celebboutique.com/aurora-white-p...

← Reply  ⇄ Retweet  ★ Favorite

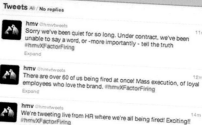

**Tweets** All / No replies

**hmv** @hmvtweets                                    11m
Sorry we've been quiet for so long. Under contract, we've been unable to say a word, or -more importantly - tell the truth #hmvXFactorFiring
Expand

**hmv** @hmvtweets                                    12m
There are over 60 of us being fired at once! Mass execution, of loyal employees who love the brand. #hmvXFactorFiring
Expand

**hmv** @hmvtweets                                    14m
We're tweeting live from HR where we're all being fired! Exciting!! #hmvXFactorFiring
Expand

## HMV

Losing your job sucks, man. But lemme tell you, if I'd just lost my job like this dude did at HMV, and I controlled the company Twitter account, then I'd be blowing up all sorts of mayhem. Total respect.

## PORNHUB

You would think Twitter accounts of porn websites could get away with pretty much anything, right? WRONG! Urging people to watch 'Ebony' porn to celebrate Martin Luther King Day is just messed up. Besides, if that is the criteria, I celebrate it every day anyway . . .

 **Pornhub Katie** @Pornhub                     Jan 20
Happy MLK. In honor of his death, make sure to only use the Ebony category today.
Expand                    ← Reply  ⇄ Retweet  ★ Favorite  ••• More

 **@RedCross**
American Red Cross

Ryan found two more 4 bottle packs of Dogfish Head's Midas Touch beer.... when we drink we do it right #gettngslizzerd

8 minutes ago via HootSuite  ☆ Favorite  ✓ Undo Retweet  ↩ Reply

Retweeted by PaulCostanzo and 11 others

## RED CROSS

Keeping up with all of your social-media accounts can be hard work. There's not only Twitter, Facebook, Instagram and SnapChat, but on some you have more than one account. It's all enough to make your brain melt. But when one of your accounts is for the RED CROSS, you might want to double check whether you're actually on your personal account, before tweeting about 'gettng slizzerd.'

## AMERICAN APPAREL

When I was still in my dad's nutsack, a spaceship called Challenger exploded and killed everyone on board. It was no laughing matter. And it definitely wasn't something that would encourage you to buy any clothes. Still, that didn't stop American Apparel, who decided that this was just the type of thing they were looking for to sell skinny jeans to hipsters. 'Cause a disaster is, like, so cool. How did that work out for you guys? Guys . . . ? Guys?

## US AIRWAYS

Sometimes companies can mess up in the real world, as well as the online world, all at the same time. Check out this tweet from US Airways. After a passenger complained on Twitter about their service, US Airways posted a seemingly innocent response, as well as a picture of a woman inserting a model airplane into her vagina. She should have flown 'Virgin' . . . What?

**US Airways** @USAirways                    ⚙  Follow

@ellerafter We welcome feedback, Elle. If your travel is complete, you can detail it here for review and follow-up: pic.twitter.com/vbeYgCuG25

← Reply ⇄ Retweet ★ Favorite ••• More

# WHEN THINGS GO VIRAL!

It's every YouTuber's dream to have a video go viral.
A viral video can take you from recording videos as a hobby to being a total online playa. Man, I remember the first time one of my videos went viral, and it was wild. Back in 2011, I was generally getting around 10,000 views a time on YouTube. That was cool, but it definitely wasn't anything to get me creaming my pants about.

But that all changed thanks to my boy Heskey. He was such a shit player on FIFA, and for some reason always pulling a funny face, that I decided to do a video completely ripping the piss out of him (sorry, Heskey!). And that video went down well. *Really* well. Before I knew it I had rocketed past 10,000 views and my eyes were glued to the screen, watching my viewing figures go up and up. I totally lost my mind, and I think it was the first time that my mom and dad were impressed by my videos.

Before long it reached 100,000 views, and had gone viral, eventually reaching over 4 million! If it wasn't for that Heskey video, who knows if my YouTube career would have taken off. It was a total game changer.

Yet for some people, going viral is the last thing on their minds. Just check out some of these guys below, who were simply minding their own business, getting on with their lives, and inadvertently became internet superstars in the process. Some people can make videos over a lifetime without getting anywhere near these sort of hits. It goes to show that some people get all the luck . . .

## THE STAR WARS KID

Oh, man, this was way funny, and probably the first time a video went properly viral. Back in 2002, a Canadian high-schooler called Ghyslain Raza decided to re-enact a *Star Wars* light-sabre routine using a golf-ball retriever. However, this poor guy didn't know he was being filmed, and before he knew it the video was leaked online and had close to a billion views, with him swiftly becoming immortalised as 'The Star Wars Kid'. This shit properly got out of hand, as while there was a petition for him to be in a *Star Wars* film and he was invited on talk shows and shit, he also received some hard-core hate. Props to my man Raza, though, as he flipped that shit on its head, and became a top advocate against cyber-bullying. I might have to give this guy a call one day . . .

## GRUMPY CAT

This little dude's face is all over the show. She's a bona fide playa in the online world and you'd be forgiven for thinking it was all part of a carefully crafted corporate plan. But it turns out that the phenomena of Grumpy Cat merely started with her owner, Tabatha Bundesen, getting a cat with a grumpy face and her brother posting a picture of her on Reddit for LOLs. Soon she had a Facebook page with 7 million likes – which is more than me for fuck's sake – was invited onto all the big talk shows, had a book and even a movie! Apparently, the Grumpy Cat empire has even made over $100m in just two years. Dayum! There's a lesson in this for all of us: we're dumb fucks and we need to get ourselves a grumpy-looking pet, pronto!

## IDIDNTKILLLUCY

The internet is full of stupid people. We all should know that by now. As a result of these melons, sometimes you can go viral without even doing anything. Remember when peeps were going crazy over Bobby Beale killing Lucy in *EastEnders*? Well, when that was revealed peeps flat-out lost their minds, and started to tweet abuse to @bobbiebeale, who lives in California, and has never watched *EastEnders* in her life. While she started a hashtag #ididntkilllucy, guys around the world started to follow her, purely because she was so hot!

## KISS CAM

Sometimes going viral is the least of your problems. Check out this dude, who was minding his own business, watching a Houston Rockets basketball game with his girl, when the kiss cam suddenly picked them out. Now, normal procedure is for the two to kiss for the camera, but this guy's girl is obviously on her period, as when he leans in she not only refuses, but slaps him across the face and then, for good measure, she pours popcorn and a coke over his head. Cold! Thankfully, the guy was sitting next to a really hot brunette, who he decided to kiss instead. Cue the whole stadium laughing, all of America watching on TV, the clip going viral, and this dude probably getting dumped. Still, he definitely had the last laugh.

## THE WEALDSTONE RAIDER

I fucking love this dude! And this just goes to show, you gotta be careful what you say and do in public, as you never know when there's a camera phone up in your grill. Back in 2013, Wealdstone

FC fan Gordon Hill was watching his boys play Whitehawk FC. Now this ain't a mad derby like Millwall versus West Ham or nothing – it's two small non-league teams, playing in a small field, probably watched by, like, ten peeps. Still, my boy Gordon was in the mood for some aggro, so when a Whitehawk fan pissed him off, he kicked off, uttering the genius line, 'You want some? If you want some I'll give it ya!' This shit went viral fast, and turned Gordon Hill, a builder, into the fearsome 'Wealdstone Raider' with over 100,000 followers on Twitter, a single in the charts, and a nice sideline in nightclub appearances.

## ANTOINE DODSON

This story just goes to show that sometimes some good can come out of the most fucked-up situations. After my boy Antoine gave an interview to an Alabama news reporter following the attempted rape of his sister, peeps started to notice that, despite it being a damn serious story, he had a mad way with words. Like, 'He's climbing in your windows. He's snatching your people up. So you need to hide your kids, hide your wife, and hide your husband, 'cause they raping everybody up here.'

Before Dodson knew it his interview had been auto-tuned, and set to a beat by The Gregory Brothers called 'Bed Intruder', which went viral with millions of views around the world. Soon the tune was even in the Billboard top 100, selling over 250,000 copies and providing Dodson with enough dough to move his family to a new home, in a better area. Cray!

# ONLINE DICTIONARY

Trying to understand what your mate is saying online can sometimes be like reading Chinese, but keeping up with all the latest lingo can be hard damn work. However, you don't want to look like the tool who doesn't know what's going on, so to save yourself the embarrassment I've put together a list of some popular online slang – and better yet, if you master it, it means that your parents won't have a clue what you're saying ; ) But if your parents have read this before you, then sorry, you're fucked!

**A3** – Anytime. Anyplace. Anywhere.

**ABFT** –  About fucking time.

**ADIDAS** – All day I dream about sex.

**AFK** – Away from keyboard.

**AITR** – Adult in the room.

**AMF** – Adios motherfucker.

**ANFSCD** – And now for something completely different.

**ASLP** – Age. Sex. Location. Picture.

**AYFKMWTS** – Are you fucking kidding me with this shit?

**BAK** – Back at keyboard.

**BBW** – Big beautiful woman.

**BAMF** – Badass motherfucker.

**BDOA** – Brain dead on arrival.

**BEG** – Big evil grin.

**BUFF** – Big ugly fat fuck.

**CBF** – Can't be fucked.

**CD9** – Parents are around.

**CID** – Crying in disgrace.

**CTFD** – Calm the fuck down.

**CU46** – See you for sex.

**CYA** – Cover your ass.

**DGYF** – Damn, girl, you're fine.

**DILLIGAS** – Do I look like I give a shit?

**DTF** – Down to fuck.

**EABOS** – Eat a bag of shit.

**EOD** – End of discussion.

**FOAD** – Fuck off and die.

**FUBAR** – Fuck up beyond all recognition.

**FYEO** – For your eyes only.

**GTS** – Google that shit.

**GUD** – Geographically undesirable.

**HDGFS** – How does get fucked sound?

**HSWM** – Have sex with me.

**IDTT** – I'll drink to that.

**ILY** – I love you.

**IMFKD^** – I am fucked up.

**JEOMK** – Just ejaculated on my keyboard.

**KPC** – Keeping parents clueless.

**LGBNAF** – Let's get butt naked and fuck.

**LJBF** – Let's just be friends.

**LMBAO** – Laughing my black ass off.

**MFIC** – Motherfucker in charge.

**NE14KFC** – Anyone for KFC?

**NIFOC** – Nude in front of computer.

**POMS** – Parents over my shoulder.

**PORNADO** – A porn tornado.

**PRON** – Porn.

**QYB** – Quit your bitching.

**SEG** – Shit eating grin.

**TAW** – Teachers are watching.

**TDTM** – Talk dirty to me.

**TILF** – Teacher I'd like to fuck.

**WTGP** – Want to go private?

**2QT** – Too cute.

**53X** – Sex.

**8** – Oral sex.

**?^** – Hook up?

# EMOJIS TRANSLATED

With peeps constantly using emojis in their messages, it's hard to work out what the fuck they are actually saying. Sometimes you just get messages full of weird faces, without any words in them at all, and it spins me right out. But it's alright, 'cause if you have the same problem as me I've put together an emoji translator, so now everyone knows the score. Who would have thought these stupid-ass faces could have so many meanings?

Happy as fuck!

I've done something I shouldn't, and it's funny as fuck.

You're being a CUNT!!!!!!

Hurry the fuck up!

Damn, I'm cool.

Sexy time?

Fuck, my life's hard.

You're taking the piss now.

Too smug to handle.

You are really, really, really hot!!!

Gonna throw myself off a building.

Up your bum!

LOL at you.

You're being mean!

I hear you, but I'm

Vacation time, bitch!

Let me stop you
right there.

Let's get fucked up!

I smell bullshit.

Hey, it's me : )

Peace bro.

We big pimping tonight!

Nerd alert!

Are you Welsh?

Love you.

Oh yeah!!!
It's my birthday!!!!

Run! Police are on
their way.

We rich as fuck!
YEAAAAHHH!!!!!

Fat fuck!

Nando's?

Check out my mad LOLs!

You're being a pain in the ass

Fancy something to eat?

I'm being funny (although
this should probably never be
sent to a black person, LOL).

Kiss my dick.

Bro Fist.

Fancy a beer?

You smell!

I'm gonna blow you away!

Bravo, you clever twat.

# KSI EMOJIS

Going through all those emojis made me realise that there are some bad-boys that desperately need to be added to the mix. So these, ladies and gentlemen, are some I'd like to see introduced pronto!

1. KSI EMOJI – You're a tool like KSI!

2. BEAST MODE EMOJI – RAAAAHHHH! Let's rip this shit up!

3. HYPER EMOJI – I'm flat-out losing my mind today.

4. SWEATY GOAL EMOJI – You lucky bastard!

5. FIFA-RAGE EMOJI – Fuck this console! Fuck this game! Fuck this sport!

6. MIDDLE-FINGER EMOJI – Fuck you!

7. WANKING EMOJI – Ready to blow!

8. ZOMBIE EMOJI – Dead as fuck today!

9. SIDEMEN EMOJI – My boys got my back.

10. BLACK EMOJI – Yo! You're black!

11. CRY-WANK EMOJI – Thinking about my ex.

12. PERV EMOJI – Dude, that girl is too young for you!

13. KANYE EMOJI – I'll do WTF I want, when I want, and ain't nothing you can do.

14. AWKWARD-MOMENT EMOJI – Shit, this is bad.

15. WALK OF SHAME EMOJI – Yo! I scored last night!

16. ONE-NIGHT-STAND EMOJI – High five for the good time. Let's never speak again.

17. VIP EMOJI – Oh yeah, we flat-out big pimping tonight!

18. HANGOVER EMOJI – Never drinking again.

19. SPUNKFACE EMOJI – Dude, I've just spunked in your face.

20. DICK EMOJI – You, my friend, are a dick!

21. SHARK-ATTACK EMOJI – HA HA! Don't bite, mate, just jokes!

22. KFC EMOJI – We hitting the Colonel!

23. CATFISH EMOJI – I am completely fucking with you!

# HISTORY, ACCORDING TO THE INTERNET...

Back in my school days I would always search the internet to get the answers to my homework. And most of the time it did the business. But you gotta be careful, as there is a lot of crazy talk online that can leave you looking ridiculous. Just check out my homework below, with all the information taken from legit websites!

## In 1,000 words summarise the causes of the major events of the Twentieth Century

Well, first of all, there are these dudes in some group called The New Order (who sang a pretty cool soccer song in 1990), and they control everything: governments, media, even KFC. Apparently they are all lizards as well and they run the world from Denver Airport. If you're wondering why you've never heard of them, it's 'cause they put fluoride in your water to control your brains. Now I don't drink water so I know their game, man.

Anyway, these guys have a lot to answer for as firstly they started World War One by shooting the lead singer from a band called Franz Ferdinand, which is cool because their music is pretty lame.

Then some guys called Hitler, Churchill and Stalin, who were all lizards, also started World War Two, so they could make loads of money selling weapons and oil. This is for real! When the Japanese bombed Pearl Harbor the Yankees damn well knew about it for days before but did nothing, man. They even had some pro camera-guy filming it all in color so he could show the public how messed up the Japanese were, and all to get them psyched for the war. Cray!

Hitler and the Nazis were doing some mad ~~shit~~ stuff all during the war. He had a base on the Moon, although I'm not sure if this is possible as the Moon is only a hologram. He could turn sand into gold (that must have been easy as he was an avatar of the Indian god Vishnu), and he even built a U.F.O. He must have been crazy mad, tho, as he only had one ball.

When the war ended in 1945 most peeps thought Hitler committed suicide. As if! He flat-out got into a submarine and went to chill in Argentina, man. He's still alive and all. Last year he was 125 and he's still ruling the world with the other lizards.

But after the war another lizard came along, and this guy was worse than Hitler. His name was George H. W. Bush, and he was a Nazi too. He was the son of some accountant, who worked for an old-skool inventor called Nikola Tesla, and they sent him to America when he was 14 so he could run the CIA. This guy then went proper crazy. He arranged for some President Kennedy to be murdered so he could become president himself, and in 1990 he started a war with Iraq, as their leader Saddam Hussein had a stargate, which let him travel around the universe, and Bush wanted it real bad. I can't blame him for that, man. That stargate sounds boss.

When this Bush guy got his stargate he was out of control, as he then gave loads of weapons to this terrorist called Bin Laden, and told his son, George W. Bush, who was President a few years after him, to fly planes into the World Trade Centre so he could

kick off some more wars with Iraq and Afghanistan. However, Bush Jr didn't listen, as he blew the World Trade Centre up with dynamite instead and faked the planes flying into it. Good thinking, Bush. Despite pretending to be kicking off at each other the Bushes and Bin Laden are still homeboys, even though the media said Bin Laden is dead. Lizards can't die, fools!

Anyway, before all that happened America tricked the world in 1969 by pretending they put people on the Moon. It was all fake, man! It was filmed in a studio in Los Angeles so that America could mug off the Soviet Union, who they were having some major beef with at the time. LOL at the Soviet Union not knowing the Moon is a hologram!

It seems the 1960s was all for jokes as there was this band called The Beatles, and one of their singers was a guy called Paul McCartney, who Kanye discovered! Anyways, the real McCartney died in a car crash in 1967 but then Kanye and his homies put a lookalike in his place. I suppose it don't matter as Kanye was still writing him some phat beats.

Soon after, the media told everyone that some fat guy from Las Vegas called Elvis had died. HA HA! This was a major LOL. That ain't true either. Elvis went to work in some fish-and-chip shops, and even made an appearance in Home Alone 2!

But after all the pisstaking messing around in the 60s and 70s America, Bush had enough of the jokes so he decided to

invent AIDS. No lie. This meant that the drug companies could make loads of dollars pretending to try to cure it. They already got the cure ready to roll but they'd all be working in McDonald's tomorrow if nobody was ill no more. That's why they don't want no one smoking weed as they know it can cure all the diseases in the world.

Thankfully, the lizard Bushes ain't running stuff no more as there is this other lizard called Obama who is now in control. However, this Obama has some skillz himself as he can control the weather. Serious! In 2013 he sent a tornado to Oklahoma and killed 24 people to take some of the media heat off him. Why can't Obama bring some sun to Britain? That would be sick!

If you want to find these lizards then they apparently live in another world under the earth. That's right, fools. The earth is hollow and they all live under us. You can even visit them through entrances at the North and South Pole, so let's have a school trip there instead of Stone Henge! Seeing the lizard world would be sick!!!

GRADE: F
JJ, please see me after class!

## LOL AT YOU!

Alright, I think I've made my point that the internet can fuck up your shit, big time. And I've definitely shown you how it's fucked up my life on a regular basis. Man, sometimes I think my life would be easier if the internet wasn't invented, but then I'd be homeless – so that would be shit.

Anyway, we've all enjoyed some serious LOLs at my expense so I'm flipping the tables on you guys now, as I'm in need of a good laugh. So, I want you to screenshot your most fucked-up, embarrassing, social-media fails, and tweet them to me at @KSIOlajidebt, with the hashtag #KSIFails. As always, those tweets that make me piss my pants will get re-tweeted so the whole world can enjoy your epic fail!

## OLAJIDE OLATUNJI
born on 19 June 1993

Timeline | Videos | Photos

**JIDE OLATUNJI** So proud of my beautiful family **OLAJIDE OLATUNJI, DEJI OLATUNJI** and **YINKA OLATUNJI**

**OLAJIDE OLATUNJI** From now on we seriously need to start dressing differently! This is like looking at black 'Where's Wally!'

**OLAJIDE OLATUNJI** Gonna get wasted this weekend and score some chicks.

**YINKA OLATUNJI** JJ, that is very demeaning to women. And can you go to sleep soon? The bed is creaking and it's keeping me and your dad up. And remember to use tissues. I'm fed up of washing your socks!

**OLAJIDE OLATUNJI** shared **KSIOLAJIDEBT's** video

My new video busting on Heskey is blowing up!!!!

 **OLAJIDE OLATUNJI** Likes **ELGATO** 👍

**OLAJIDE OLATUNJI** is friends with **GUDJONDANIEL**

 **OLAJIDE OLATUNJI** Likes **THE BEAST** 👍

 **OLAJIDE OLATUNJI** Quit school today to go full-time on YouTube. School can suck my dick!

# ONLINE REVOLUTION

Alright then. By now you're probably thinking we should just burn down the world and get this shit over with. I hear you. The internet is one of the greatest inventions of all time, and tools like myself, as well as some of you, are fucking it up. So, what can we do about it?

A lot, actually. If we want to save the next generation from our tool fate, then we all need to Man the Fuck Up and start an online revolution, so that as we improve the internet, we can improve ourselves in the process. Fuck, I actually sound like Mandela or something. Maybe I'm on my way to being cured already : )

# FACEBOOK UPDATES

Whenever Facebook has an update the whole world loses its mind. Everyone bitches so much about it and Facebook must wonder why it bothers. But don't worry, Facebook, I got your back. If you really want to sort your shit out then just watch and learn . . .

## 'SHUT THE HELL UP' BUTTON

The 'Like' button gets a lot of business on Facebook, but I'm certain that a 'Shut the Hell Up' button would do even better. Finally, you could dislike all of your friends' humblebrag statuses, as well as companies and celebrities that you despise.

## NO HATE

If you ever take the time to check out the comments to my videos and posts you will see that amongst the love, the trolls are having a field day. So, why not have an option where you can turn all of the hate into love? This would drive the trolls nuts and make for some very pleasant reading for me : )

## PHOTO EXCHANGE

Why do people post pictures of their babies all the time? Sure, it might look cute to you, but to the rest of us it is just boring as fuck. Facebook needs to have an option where it immediately turns all babies into little dinosaurs. This would be far more entertaining!

## WARNING SYSTEM

This would stop so many people making dicks out of themselves, especially those humblebraggers and oversharers. Imagine if, as soon as one of those fuckers had just written their status, and were about to press submit, Facebook could intervene with: 'Warning, this status has the potential to make you look like a complete tool!' They'd definitely have to think twice before posting, and it would save us wasting our time reading it.

## FACEBOOK FOR OLD PEOPLE

Now, I've already shown you how annoying parents can be on Facebook, and I'm damn sure there is not a kid alive today who thinks Facebook is a better place with their parents on it. So, why doesn't Facebook have a separate site for old people, and ban anyone over 30 from the real site?

## BREATHALYSER

Forget limiting this to just Facebook – you shouldn't be able to post anything online unless you pass a breathalyser test. This would definitely cut down on you looking like a total idiot and wanting to kill yourself in the morning.

## TURN TROLL PROFILE PICTURES INTO DICKS

Seriously, anyone who has had three complaints for being a troll on Facebook should have their profile picture automatically turned to dicks! This would stop them talking shit – overnight.

# KSI DEFENDS THE INTERNET

Can you imagine all the crazy shit you could get up to if you controlled the internet? You would have access to everyone's bank, social-media and email accounts, and you could charge people to use their favorite websites. Man, you could even get people to shut the fuck up if they were pissing you off. And that's just for starters.

While being able to control the internet would be sick, it's no fun if someone else is calling the shots. And right about now there are a few corporations and governments who are getting too big for their boots. Soon the internet will be just like school, with teachers telling us what we can and can't do. Fuck that, man. We need to keep this shit real!

So, before the internet gets real shit, real fast, I've flagged up some areas that we need to defend like a John Terry sliding tackle...

## NET NEUTRALITY

In real life most of us are down with treating everyone equally. Shit, this isn't apartheid-era South Africa. And since the dawn of the internet that has always been the case, with all internet traffic and users being treated the same. It's why the internet has become such a cool place to chill.

But now some internet companies want to change all that, and want to be able to legally discriminate against user, content, site or platform application. For us dumb fucks, this basically means that they can choose to slow down access to certain websites, and/or charge us more to access them.

With the internet being open to everyone, we've managed to come up with some pretty cool shit. Would young tech whiz-kids have been able to innovate and invent websites if they didn't have easy access to everything they needed online? Would YouTube be such a cool place if everyone couldn't watch?

So, what I'm saying is, things are fine as they are right now, and we don't need any internet companies suddenly telling us what we can access, and how much we have to pay for the privilege. The internet should be open to everyone, just like a 24/7 McDonald's!

## PRIVACY

For those of you who were asleep in English, you might have missed out on a book called *1984*, written by a dude named George Orwell, which was basically about the government spying on everyone and controlling their lives. Sounds like it was based on some of my ex-girlfriends ; ) Now, I can't remember the details of the book, because I was one of those who was asleep, but this scenario is actually happening right now, and it's scary stuff.

You may have heard on the news that the US government already keeps track of all of our emails, messages and social-media posts, while the likes of Google record everything we search for, as well as every site we visit. I think we need to turn the tables and put some rules in place for governments and corporations so we know what the fuck they are doing, 'cause right now, at the click of a button, they could show everyone the porn you have been watching, even if you have deleted your history like a pro. Makes you think, doesn't it?

## BUY OUTS

I remember there used to be a kid who hung around school selling weed (not that I ever went near the dude, as I was scared shitless of him). If anyone else ever tried to hustle in on it he would give them a smack and tell them they could only sell it on his terms. This meant that he could name his price, sell complete shit, and could basically do what the fuck he liked. And right now the internet is in danger of heading the same way.

Every single week there seems to be a story about another company spending billions of pounds on a website/app. Google has already bought Android, Motorola and YouTube. Facebook bought Instagram and WhatsApp. Now, there might seem nothing wrong with this, but if just a handful of companies control all of the most popular websites on the internet, as well as access to the internet itself, then they can do as they damn well please, which could lead to less choice, less diversity and higher bills. Not to mention some scary privacy issues. So, while there are laws and stuff in place that are meant to stop this from happening, they've got to be better, 'cause before we know it the school bully will be running the show.

# BACK TO THE FUTURE

The internet is one sick invention. Try to imagine a world without it. It would be like living in the Stone Age, or anywhere a 3G signal is a joke. But let's just hold the fuck on for one minute. While the internet is a big part of all of our lives, peeps seemed to get by just fine before it was invented. So, I decided to go back in time, check out some things people used to do before, and bring back the very best of them.

## MEET UP WITH FRIENDS

Instead of just chatting shit online to each other, people used to actually arrange to meet up in real places and talk. Cray! But this is one I'm definitely down with. It might even get me out of the house once in a while.

## EAT A MEAL WITHOUT TAKING A PICTURE

Before Instagram people would eat without taking a picture of their food. And it turns out that their meal actually tasted just as good! Who would have thought?

## PRANK A MATE

Tricking a friend online can be major LOLs, but back in the day your regular pranksters had no choice but to do it in real life. And the bonus with this is that you get to witness your mate's reaction up close and personal. Priceless.

## CHAT UP A GIRL

These days we can hit up loads of girls online, all at the same time, without getting brutally rejected to our faces. However, when it comes to real-world meets, most of us are fucking useless. But before the internet, guys actually had to lay the groundwork by approaching girls in actual places, and talk to them! Scary stuff. However, it meant guys had to grow a pair, and improve their real-world game in the process, which, after all, is where it really counts.

## READ A BOOK

Way back in the day, before the internet, people used to read books to get their kicks. So, congratulations you time-travelling mo-fos, you're already ahead of the game, as right now you are reading a book just like your ancestors used to. Who would have thought I would get you bitches to actually read! LOL. I bet you feel like Einstein or something.

## WANK

Wanking without the internet? That sounds like something Bear Grylls might do on one of his expeditions. However, while I'm not suggesting you should shut down all of your online porn, sometimes it's good to mix your wanking strategy up, and use your imagination. After all, writer William Arthur Ward once said, 'If you can imagine it, you can achieve it!' And there are some things in my wanking imagination I would definitely like to achieve  ; )

## GO TO A CONCERT

I know, we still do this today, but check out the audience next time you're there. Most peeps are either constantly taking pictures and then immediately posting the pics online, or they are watching the whole show through their phone/iPad, while they film it. So, next time you're at a show, put the goddamn phone down and just enjoy it au naturel, for fuck's sake.

## LOOK GOOD

I know we all look like models online, but people actually used to have to do the whole #nofilter thing for real. So, rather than spend all of your time perfecting your look for social-media, spend some of it making sure you don't look like dog shit in real life.

## HAVE A NAP

That's right. Just turn off your phone, shut down your computer and have the best nap of your life without constant interruptions.

## PLAY SPORTS

Can you imagine if for all that time you spent playing FIFA you actually played real soccer? You'd probably be the next Ronaldo, and you'd certainly be a lot fitter. So, organize some five-a-side games with your mates, and score some sweaty goals in the process. At the very least it will stop you becoming a fat fuck!

# #Days of the Week

Before social-media we were happy enough to just call the days of the week by their regular names. I mean, WTF else would we call them? But then hashtags came along and tore that shit right up. These days we've got #MondayBlues, #TransformationTuesday, #WayBackWednesday, #ThrowbackThursday, #FollowFriday, #SaturdaySwag and #SelfieSunday.

But let's just hold the fuck on for a minute and analyze this madness. We could be doing all sorts of amazing stuff online. Are we seriously saying the best we can fucking do is #SelfieSunday, where tools spend the whole day posting selfies? Give. Me. Some. Goddamn. STRENGTH!!!!

We've gotta be doing better than this, man. So, what I'm saying is, it's time to rip up the rule book and start over with the hashtag days of the week – and this here is what I'm talking about.

## #FundayMonday

No one likes Monday. It's a pain in the ass and probably the worst day of the week. So why don't we start off with some serious LOLs? That's right, from now on we're gonna make Monday a big old barrel of laughs by posting a joke or funny picture. It's as easy as that. Flood social-media with some good old-fashioned gags and soon we'll get the whole world chuckling into their Coco Pops.

## #TitillatingTuesday

I know what you're thinking. And no, that's not what I'm saying, you perverted fuck! For once we are leaving tits alone. I'm saying that on Tuesdays we should be titillating the fuck out of each other with some hard-core knowledge. All you gotta do is post a crazy fact on social-media and before you know it we are all learning new shit.

## #WinningWednesday

It's the middle of the week and by now we are all fucked. So what we need is a little pick-me-up, other than a KFC Bargain Bucket. We gotta inspire each other so we can all get through the rest of the week. Personally, I love hearing stories about crazy-ass people who triumphed over adversity. For instance, check out Arnold Schwarzenegger. That dude rocked up to America with nothing more than his big muscles and a badass dream. He went on to win Mr Universe multiple times, become the biggest movie star in the world, and even be Governor of California. Sick! Let's post more stories like this on Wednesdays to give us the kick up the ass we need!

# #ThursdayTunes

Oh, yeah! We're getting close to the weekend now and you can almost taste that Saturday vibe. And what better way to gear up the excitement than by filling social-media with your favorite tunes? Who knows, you might discover something new, or even hear a song you totally forgot about. Everyone loves music as well, so we'd all be down with this.

# #Friendly Friday

Man, oh man. It's finally the weekend and you can bet your bottom dollar that I'm happy as fuck! And I know you are as well. Everyone is flat-out buzzing when the end of the week comes around, so let's spread that good feeling around the internet by bigging up your friends or people you admire. Just tag them in your tweet or status and let them know why they're one of your team.

# # Super Saturday

Here we go. We've been waiting all week for it, and it's finally here. SATURDAY!!! But, y'know, it's amazing the amount of times I gear myself up for Saturday and then wonder what the fuck I'm actually gonna do. Sure, I got my standard stuff like watching Arsenal, and hitting some clubs, but sometimes it would be good to get some fresh ideas to mix it up. So, if you're doing something cool you think other people might like just hashtag that bitch up with #SuperSaturday, and maybe we can tag along as well!

# #SexySunday

Did you really think I was gonna get through the whole week without dedicating it to beautiful women? LOL! No chance. But this is all good, man. By Sunday we are getting that dreaded back-to-school/work vibe and need to take our minds off that shit. What better way than clicking on social-media to see it full of some beautiful ladies, or guys, if that's your thing! This would soon chill you the fuck out and set you up for another week ahead.

# THINGS THEY SHOULD TEACH YOU IN SCHOOL ABOUT THE INTERNET

I sometimes wonder, what did I actually learn in school that I still use in everyday life?

I can tell you now, all that shit about amoebas and algebra was completely pointless. In fact, school was pretty much a total waste of my time. However, with so much of everyday life now taking place online, schools should be teaching kids stuff that might actually be helpful.

To shake this shit up I decided to put together an education manifesto. If you like what you read, why not screenshot the page and tweet it to @david_cameron with the hashtag #ksieducation or post it to: The Prime Minister, 10 Downing Street, London, SW1A 2II. Who knows, man, maybe they'll invite me onto the Cabinet. That would rock!

# KSI'S EDUCATION MANIFESTO

Dear World Leaders,

It's your boy KSI here, just dropping you some ideas for fresh classes in school. Me and my fans think this would be pretty sick, so why don't we meet up in Nando's to discuss it? Mine's a PERi-PERi chicken, extra hot ; )

CODING: Apps are big business, man, and are making their developers crazy bucks, not to mention providing loads of jobs. So why don't we have coding classes so us kids can get in on the action? How else can we afford Lambos these days!

GAMING: If schools are gonna teach PE to try to make kids pro ballers, or keep them fit, then they should teach gaming classes as well. Hear me out, now. These days there are a lot of pro gamers, like NaDeSHoT, who is pulling in some serious coin playing Call of Duty, and I made my career through playing FIFA. And even if you suck at playing games it's still proven to help improve eye-and-hand co-ordination. Best of all, no kid will ever hand in a sick note for this class.

VIDEOS: Online videos are everywhere these days, and I'm not just talking about YouPorn ; ) Most websites, in most professions, have some sort of video, not to mention the millions of videos that are added to YouTube as general entertainment. So, learning how to shoot and edit videos is a must for any career, not to mention damn good fun.

HACKING: This might sound crazy, but a lot of shit is going down due to hacking. Remember when Sony Pictures got hacked? So, to protect ourselves from any future attacks, and to attack others if necessary, I think we need to know how to hack. Imagine if one of your crew could hack Putin's phone and get his dick pics, LOL. You could do whatever you wanted!

SOCIAL-MEDIA: I hear that employers check out applicants' social-media profiles these days to see if they are up to the job. That's cold stuff, man, as so many people post things that make them look like complete tools. It's no wonder so many peeps are out of work. That being the case, you gotta teach kids the dos and don'ts of social-media. If you need any help check out my mom's guide to online etiquette!

ONLINE DATING: While we are on the subject of social-media classes, some online-dating classes would be pretty cool as well. Too many dick pics are getting leaked online these days, man, so that's a whole class in itself. Seriously, though, some Tinder advice would be great, otherwise kids are just gonna spend their lives wanking in their bedrooms and that will be the end of the human race!

Ok, DC, that's it for now. Give me a call and let's talk this shit through.

Peace!

Your boy,

KSI

# KSIBOOK

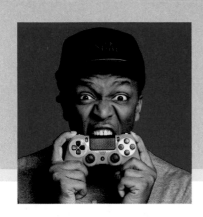

## OLAJIDE OLATUNJI
born on 19 June 1993

**Timeline** | Videos | Photos

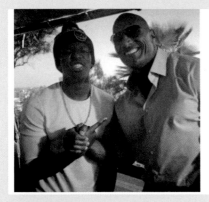

**OLAJIDE OLATUNJI** Dream come true! Interviewing The Rock! #nofilter

**OLAJIDE OLATUNJI** checked in at **LAMBORGHINI**

**OLAJIDE OLATUNJI** WOW! 9 million subscribers and counting on **KSIOLAJIDEBT!** Thanks :)

**OLAJIDE OLATUNJI** LOL! Check me out!! All guns blazing, ready to destroy The Ox at FIFA!

**OLAJIDE OLATUNJI** checked in at Leicester Square

**JIDE OLATUNJI** Yinka, looks like JJ is out for the night . . .

**YINKA OLAJIDE**  ; )

**JOSH ZERKER** is ripping up Las Vegas with **OLAJIDE OLATUNJI**

**ETHAN PAYNE** shared **KICK TV GAMING's** video

**ETHAN PAYNE** Dude, have you seen what Gudjon has said about you? Thought you guys were tight?

**OLAJIDE OLATUNJI** WTF!!!! I'M GONNA KILL THIS BITCH!!!

# KSI'S (KFC) BUCKET LIST

We're just about done with this book, bitches, and by now I hope you know a thing or two about me, as well as how to avoid becoming a tool. But before we lock this down I've still got some plans for the future, beyond eating KFC, that I want to share with you. Who knows if it will all come true, but I never thought I would ever write a book, so you never know! So, before I check out, this is what I aim to do:

## 1 DROP A RAP WITH DRAKE

Out of all the rappers in the game, I gotta say that Drake rips that shit to shreds. This dude is totally legit and it would be unreal to drop a rap with him. Hell, I'd be happy just to chill with him, man. He's a cool dude!

## 2 ACT IN A MOVIE WITH THE ROCK

The Rock has been my idol since I was a kid, and it blew my mind when I got to meet him in LA. But I would love to go one better and actually be in a movie with him. Fuck, we could do some crazy shit! A cop movie like *Bad Boys* would be hilarious. C'mon, Dwayne, let's do this shit. You be good cop, and I'll be bad cop.

## 3 EAT EVERYTHING ON THE KFC MENU IN ONE SITTING

When I hit up the Colonel I usually just stick to the tried-and-tested bucket of chicken. That shit is so good that I don't want to miss out by ordering something else and not liking it. But KFC has a big-ass menu, so one day I want to give it all a go and see what's going down elsewhere. This probably wouldn't be good for my heart, waistline or wallet, but I love a challenge!

## 4 SEE ARSENAL WIN THE PREMIER LEAGUE

Do you know when the last time Arsenal won the Premier League was? 2004! Two thousand and fucking four!!! That's half a lifetime ago, when stuff like YouTube, Facebook and iPhones hadn't even been invented. For fuck's sake Arsenal, you gotta win it at least once in my lifetime so I can tell all these pain-in-the-ass Manc and Chelsea fans to shut da fuq up and suck my big black dick!

## 5 MEET MY DREAM GIRL. WHO KNOWS, MAYBE I'VE MET HER ALREADY . . .

Y'know, I like a good wank, but sometimes I think all that cum just gets wasted on a tissue and could probably be put to far better use. While I'm loving life right now, it would be cool to meet someone who gets me and could put up with me, LOL. But it's hard, man, 'cause as soon as they check out my YouTube videos and see me humping my dead nana, they think I'm a serial killer or something : / So, any ladies out there who are up for the challenge, make sure you say hello : }

## GO TO TOMORROWLAND

Tomorrowland is an electronic dance festival in Brazil and it always looks proper mental, with some badass acts, cray peeps, plenty of sunshine and good times. Tickets are harder to get than a title at Arsenal, but I'm gonna call in some favors real soon, as I gotta get to that joint while I'm young, dumb and full of cum.

## OWN A BUGATTI

Now, I love my Lambo. That car was like my goddamn dream. But a Bugatti is such a beautiful ride. Just look at that shit. Plus, it can do over 250 miles per hour, which is mental. Priced at over $1.5 million I don't think I'll be getting one anytime soon, but I may have an idea for my next tune – 'BUGATTI! BUGATTI!'

## REACH 100 MILLION YOUTUBE SUBSCRIBERS

As I write this I've just hit 9 million subscribers, which is beyond anything I ever expected. Shit, when I first reached 1000 subscribers I thought it couldn't get any better. So, while 100 million sounds impossible, I've learned not to put limits on this type of stuff. Plus, I'm only 21, so hopefully by the time I'm 70, and making videos about false teeth and a walker, I'll almost be there.

## DESIGN A PAIR OF GIUSEPPE'S

These are hands down my favourite footwear, even if they are on the pricey side. I'm telling you, I've got a real weakness for these bad boys, and I've got some sick ideas for designs of my own. Would you guys get on board with KSI trainers? 'Cause someday soon I've gotta give it a go.

## START THE WORLD'S FIRST WANKING MARATHON

They say everyone has a special talent, and mine has to be wanking. I can go all goddamn day if I want to, and even if just dust is coming out at the end I can power through. So I think I need to display this superhuman talent to a bigger audience, and why not do it in a wanking marathon? I suppose it would work like this: all the best wankers in the world line up, surrounded by porn, with the first to blow their load being crowned the winner. Man, this actually would be funny as fuck!

If I do even half of the things on this list I will have led a pretty sick life! But first things first, I gotta stop being a tool. Man, it's gonna be tough . . .

## ARSENAL

**@harveymaw_kings If you had £70,000,000 and were the manager of Arsenal, who would you buy?**

Fuck, man, I can't buy anyone good with that. Jesus Christ, it sucks that that is actually so true. I couldn't get Hazard, maybe Sterling, and I couldn't afford Bale, no chance. In fact, I probably would get Heskey just for the LOLs and pay him huge bucks so he feels good about himself.

**@SAINTSINSEI Favorite Arsenal player ever?**

Thierry Henry.

## WTF?

**@YassineMAFTAH What if one day you wake up and BOOM! You live in Nigeria without YouTube and KFC?**

I'm pretty sure they have YouTube in Nigeria, and chicken as well, so what the fuck is wrong with you? It's all good! I would just wake up, go on YouTube and eat my chicken.

**@lucarse200 Would you drink @lindsay7_brad's piss to save a chicken's life?**

No, because the chicken will probably get killed anyway – how else would we fucking eat it? What a dumb question.

**@SpawwnieXML Would you rather have a lifetime supply of chicken and no family, or no chicken but a family?**

No chicken and a family! Duh! What fucking questions are these? I can't tell a chicken my problems. He won't put up with my shit!

**@Caspar_Lee Who is your favourite South African?**

Troye Sivan . . . Mad?

**@raniaisonfire Who is your favourite Asian?**

It's gotta be Nigahiga. He's pretty jokes!

**@5oShadesofHotch Would you rather be on *Take Me Out* or be on *Ex on the Beach*?**

Ah, good question! The thing is, with *Ex on the Beach* I wouldn't give a fuck about anyone except Seana, 'cause it would be a major mindfuck if someone was trying to get with her – it would fucking suck. So I guess that kinda answers the question, it would have to be *Take Me Out*. Man, I would love to be on that show! That would be sweet. In fact, I'm gonna look into that.

**@diouri Have you ever seen a grown man naked?**

Yes.

**@zummar45 Have you been naked in public?**

No, and now people know me I guess that means I've missed the boat on that ride, so those days are gone for good.

**@gems970 If the FBI break down your door do they have to pay for it?**

Yes . . . I think. Uhhhh, I don't really know how to answer this. I suppose if you're found not guilty of a crime then they do have to pay for it. What a waste of a question!!!

**@Jaispookiebear Will you fist me?**

Yeah, fuck it, why not.

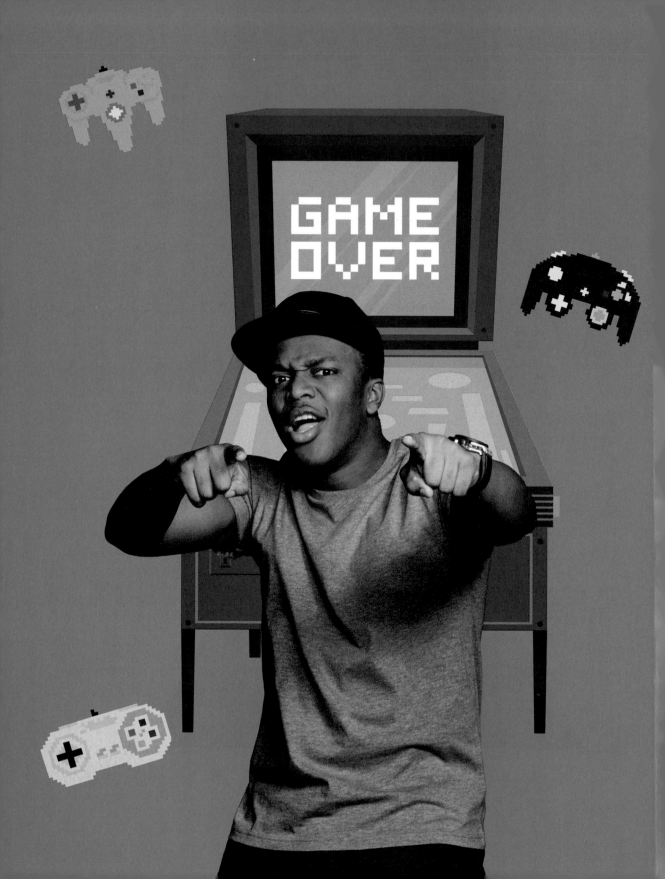

# THE END

Congrats my fellow tools. You've not only learnt some pretty important lessons, but you've even managed to read a goddamn book, you clever fucks! Sure, it might not have been Shakespeare, but does that dude talk about Tinder, FIFA and fit chicks in *Hamlet*? Hell no, so I reckon you've had a result reading this instead.

Anyway, it's just about time for me to go, but before I bounce I think we gotta recap on what's been going down. By now you've probably realized that there is a good chance you're a tool like me, and if you haven't, congratulations you boring fuck!

Being a tool might mean you make a dick of yourself from time to time, but at least you're having some fun along the way. However, you gotta remember that the internet isn't to be taken lightly. Sure, I've shown you how to make it your bitch, master the art of looking good, learn the lingo, be a Tinder playboy, as well as a YouTube kingpin, but I've also shown you the dark side. Remember, the internet is riddled with pervs, psychos, scammers, hackers and conspiracy theorists, who all want to scam you. You gotta watch your step. And you want to be damn sure you take it easy on the selfies, hashtags, auto-correct fails and viral videos, 'cause if you're not careful, people won't think you're a tool, they'll think you're a dick!

So, if there's one message I want you all to take away from this, it's that being a tool is ok. Even your parents were tools once, and I suppose they turned out alright in the end (well, some of them did anyway). But, man, be careful out there, and remember: it's all fun and games until your dick pic has gone viral.

Anyway, it's time for me to make some videos to keep you guys entertained. Now we've reached the end you can show your parents the crazy shit that is in this book, and laugh at them for buying you this madness! Peace! I'm outta here you crazy-ass bitches!

Your boy,

**KSI**

KSI would like to thank the following tools in the making of this book: James Leighton, Liam Chivers, Gordon Wise, Anna Valentine, Brian Roberts, Emma Smith, Helen Ewing, Katie Horrocks, Alice Morley, The Sidemen, Deji and Mum and Dad.

**PICTURE CREDITS**